100 DAYS OF DRAWING

SKETCH, PAINT, and DOODLE TOWARDS ONE CREATIVE GOAL

BY

JENNIFER ORKIN LEWIS

ABRAMS NOTERIE, NEW YORK

YOUR 100 DAY CHALLENGE BEGINS

Since 2014, I've been doing one 30-minute drawing every day and posting it on my Instagram, @augustwren. I would encourage absolutely anyone to carve out 30 minutes a day to do something that they love, but I realize that "every day" sounds like a super-human commitment.

So, why 100 days?

Artists and entrepreneurs alike recommend taking on a new project for 100 days. A hundred days has been called the "Goldilocks of goals": it's not so long that you feel intimidated to get started, but it's not so short that you don't have time to experiment and learn.

Doing something for 100 days also feels like a BIG accomplishment. I know that you can do it, and I want to see what you make. If you want to share, please post your drawings on Instagram with the hashtag #100daysofdrawingbook.

Even if you don't complete this book in 100 consecutive days, I hope you simply enjoy the process and make some creative discoveries along the way.

Have fun!
Jennifer

THIS SKETCHBOOK SETS YOU UP FOR SUCCESS

IT PROVIDES TWENTY-FIVE OF MY "SKETCHBOOK SECRETS"

After hundreds of days of drawing, I've come up with some go-to subjects and approaches that I love revisiting in my sketchbooks. For various reasons, they all tend to yield drawings that are surprising and fun to look at.

IT NUDGES YOU PAST THE BLANK PAGE

The hardest thing about sitting down in front of a blank page is deciding what to draw. So, for each day I offer you a different idea and in some cases a foundation drawing to finish. Your interpretation of these ideas will make your sketchbook completely unique.

IT GIVES YOU A VARIETY OF SURFACES TO DRAW ON

I'm still amazed that the same drawing looks totally different when you see it on a variety of backgrounds. A painted surface really enhances even the simplest blank line drawing. In this sketchbook, you'll find craft paper pages, black pages, and colorful washes to draw on.

1 OBJECT 8 WAYS

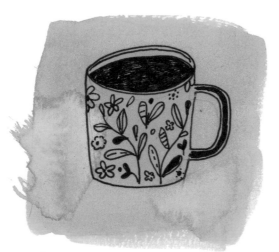

on highly-saturated backgrounds, try using just black pen.

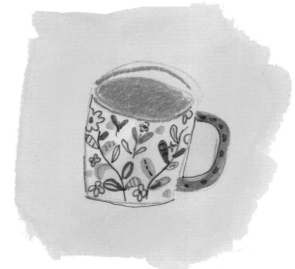

you can use a combo of marker and pencil on a lightly painted background.

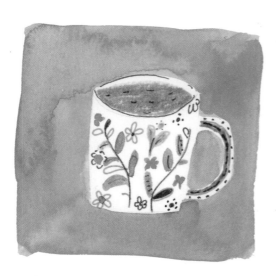

fill a white shape with color and pattern—there's no need to outline it.

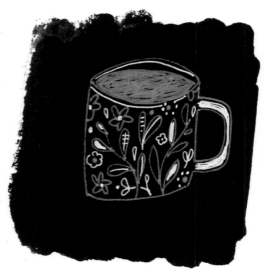

DRAW on a BLACK BACKGROUND with white and gold gel pen.

REMEMBER: use only water-based markers in this book.

This book has a variety of surfaces so that you can experiment with different drawing styles. The same object looks totally different, depending on the materials you choose.

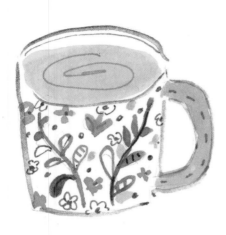

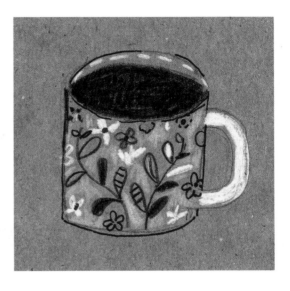

With BRUSHY black outlines, try using marker or watercolor in a loose way.

Black and white crayons and Pencils work well on BROWN craft paper.

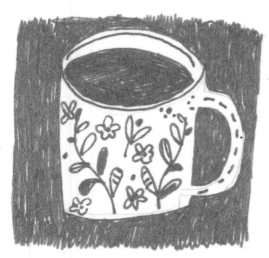

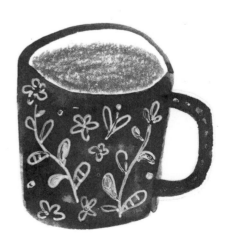

Rather than filling in an object, try coloring in the BACKground instead.

TRY drawing with white gel pen on top of a darker color.

Permanent art Markers will bleed through the pages.

CHECK OFF THE DAYS as you COMPLETE THEM.

wreaths	☐ Day 1	☐ Day 2	☐ Day 3	☐ Day 4
cups	☐ Day 5	☐ Day 6	☐ Day 7	☐ Day 8
doodles	☐ Day 9	☐ Day 10	☐ Day 11	☐ Day 12
face dots	☐ Day 13	☐ Day 14	☐ Day 15	☐ Day 16
buildings	☐ Day 17	☐ Day 18	☐ Day 19	☐ Day 20
GOLD GEL	☐ DAY 21	☐ DAY 22	☐ DAY 23	☐ DAY 24
leaves	☐ Day 25	☐ Day 26	☐ Day 27	☐ Day 28
objects	☐ Day 29	☐ Day 30	☐ Day 31	☐ Day 32
butterflies	☐ Day 33	☐ Day 34	☐ Day 35	☐ Day 36
letters	☐ Day 37	☐ Day 38	☐ Day 39	☐ Day 40
food	☐ Day 41	☐ Day 42	☐ Day 43	☐ Day 44
tiles	☐ Day 45	☐ Day 46	☐ Day 47	☐ Day 48
my day	☐ Day 49	☐ Day 50	☐ Day 51	☐ Day 52

Blue only	☐ Day 53	☐ Day 54	☐ Day 55	☐ Day 56
3 colors	☐ Day 57	☐ Day 58	☐ Day 59	☐ Day 60
headdress	☐ Day 61	☐ Day 62	☐ Day 63	☐ Day 64
words	☐ Day 65	☐ Day 66	☐ Day 67	☐ Day 68
table top	☐ Day 69	☐ Day 70	☐ Day 71	☐ Day 72
people	☐ Day 73	☐ Day 74	☐ Day 75	☐ Day 76
plants	☐ Day 77	☐ Day 78	☐ Day 79	☐ Day 80
old photos	☐ Day 81	☐ Day 82	☐ Day 83	☐ Day 84
Flower/stripe	☐ Day 85	☐ Day 86	☐ Day 87	☐ Day 88
animals	☐ Day 89	☐ Day 90	☐ Day 91	☐ Day 92
selfies	☐ Day 93	☐ Day 94	☐ Day 95	☐ Day 96
old masters	☐ Day 97	☐ Day 98	☐ Day 99	☐ Day 100

DAILY DRAWING IDEA

DRAW in a WREATH

I use wreaths all the time as a device for laying out the page in a pleasing way. It can be used to hold a quote or an image of something you find special. I love wreaths that aren't perfectly round or symmetrical. They can be monochromatic or very colorful. Going with a holiday theme is an obvious choice, but what you put into the wreath can be personal and whimsical: butterflies, flowers, and gardening tools to celebrate spring; or autumn leaves, acorns, and apples for fall.

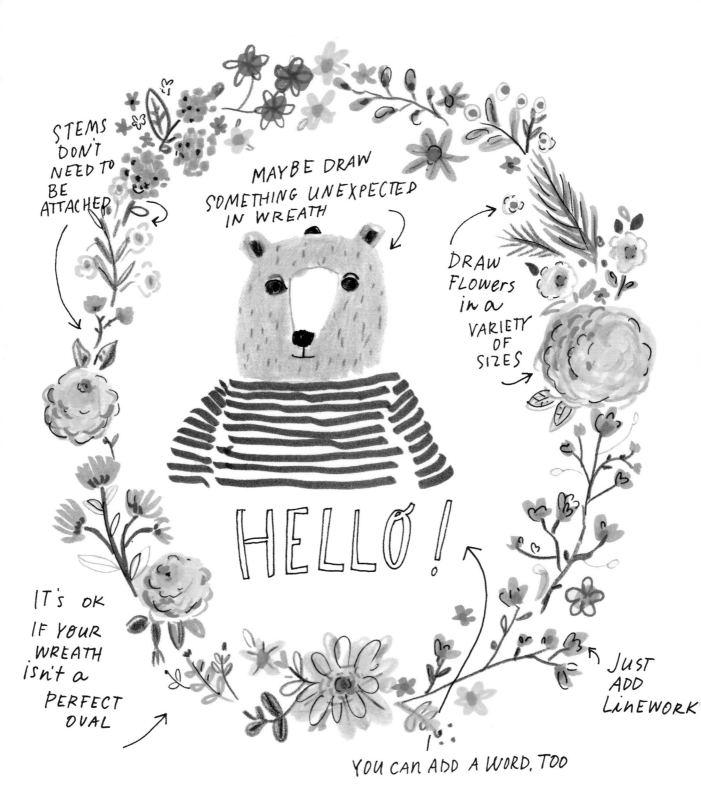

DAY 1 _/_/_

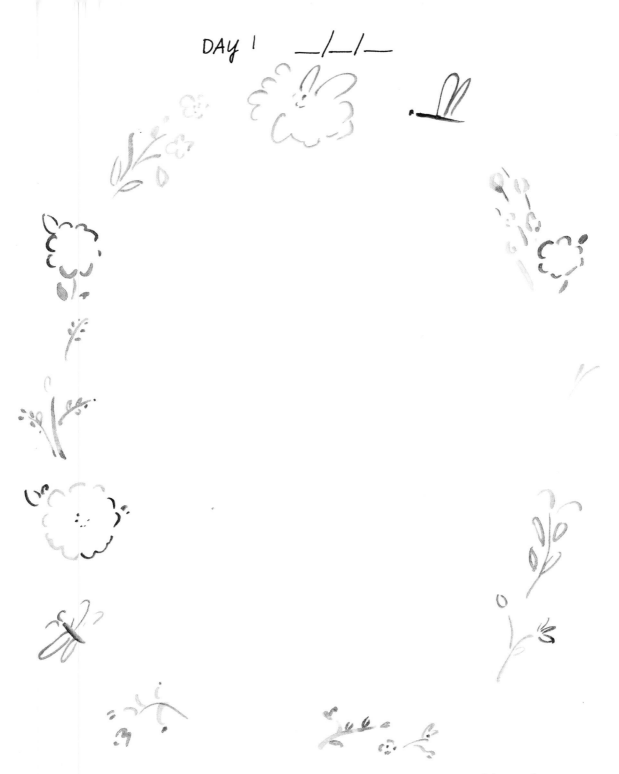

Finish this sketch with your own flowers, leaves, butterflies, birds, or anything else that comes to mind.

DO
WHAT
MAKES
YOU
HAPPY !

What makes you happy? Draw those objects in an oval around the phrase here, using two or three colors that you really love.

DAY 3 __/__/__

DRAW A WREATH, AND, IF YOU FEEL LIKE IT, WRITE ONE EMPOWERING WORD IN THE CENTER.

DAY 4 __/__/__

Create a wreath inspired by your favorite holiday. It can even be a lesser-known holiday, like National Ice Cream Day!

REFLECTIONS

Imagine a wreath inspired by someone who is important to you. Make a list of things that it could include. Maybe at some point you'll use these ideas to make a birthday card or a little piece of wall art for this person.

DAILY DRAWING IDEA

DECORATE MUGS and CUPS

Drinking vessels provide endless inspiration for drawing. I love to reference a ceramic design from the past and make it new by using unexpected colors or adding my own elements to it. The shapes of cups are so varied, so there are fantastic boundaries to work within and so much potential to play with. Sometimes, I'll decorate a cup with repeating designs, and other times, I'll draw something centered within the shape. You can also decorate a mug with a scene from a place you've been.

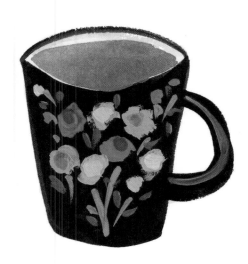
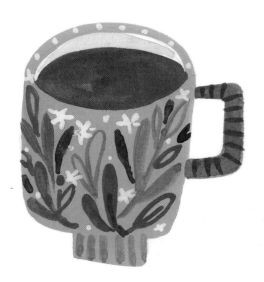

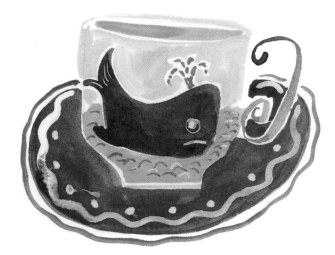
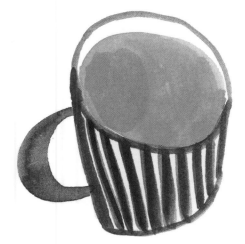
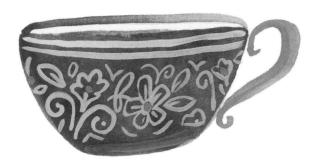

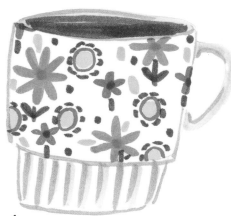

← USE LIGHT GREY FOR SHADING

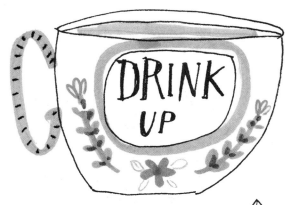

DRINK UP

PUT A MESSAGE ON THE CUP ↗

DECORATE THE INSIDE OF THE TEACUP. A TOP VIEW WORKS WELL FOR THIS ↖

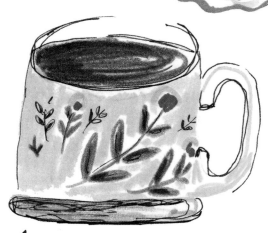

↑ TRY A VERY LOOSE VERSION

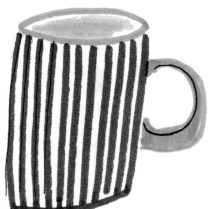

↑ SIMPLE STRIPES ARE ALWAYS APPEALING

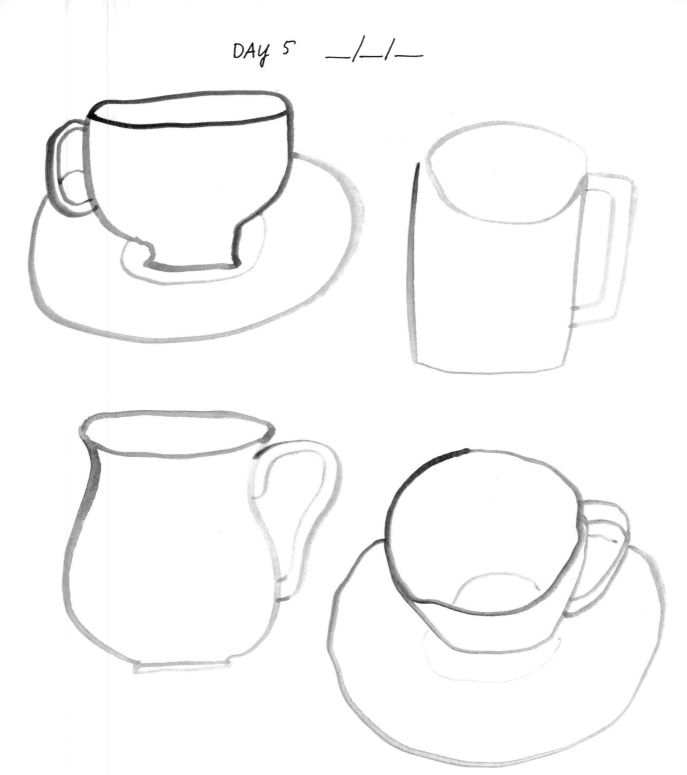

DAY 5 _/_/_

Fill these mug and teacup outlines with designs of your choice. maybe each one is themed around a place that you've lived, visited, or would like to visit.

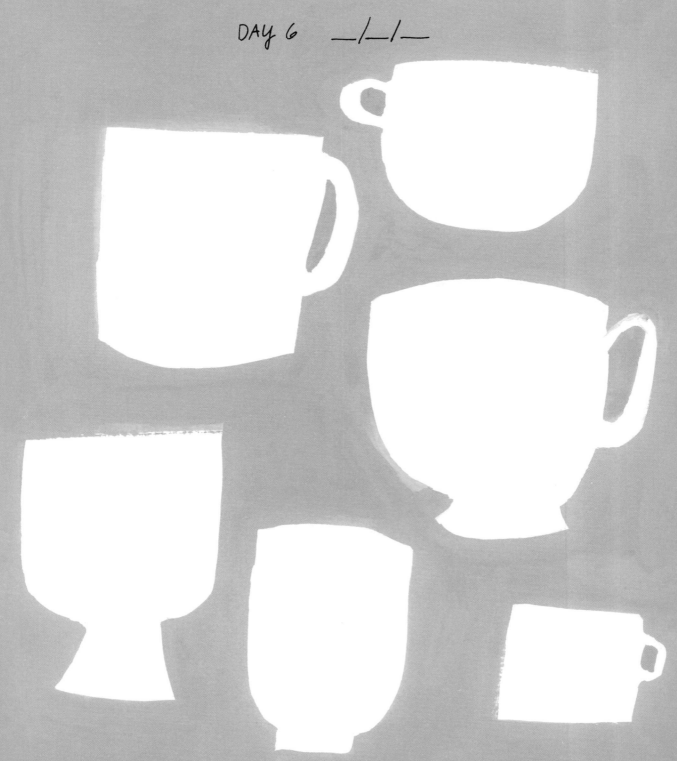

MORE MUGS FOR YOUR EMBELLISHMENTS. PERHAPS THEY SHARE THE SAME
color scheme, But each one has a totally different design.

DAY 7 _/_/_

select your FAVORITE MUG or tea CUP as your SUBJECT FOR today.
you could sketch it FROM a FEW diFFERENT angles.

DAY 8 _/_/_

Design coffee mugs for four different people. Use the same shape and add different decorations, or create unique shapes for each.

An astronomer

An activist

A modernist

A cat lady

REFLECTIONS

Do you have any rituals involving a favorite beverage: a cup of coffee first thing in the morning or an afternoon tea break? Describe them here.

DAILY DRAWING IDEA

USE BLACK PEN
on
BRIGHT COLORS

I might find a painted sheet of paper lying around my studio and I'll draw on it with black pen. The color and texture of the background takes the drawing from looking like a coloring book page to being a more complete piece of art. I tend to cram every inch of the sheet with drawings (I can't help myself) but it's ok to put just a simple image in the middle of the page.

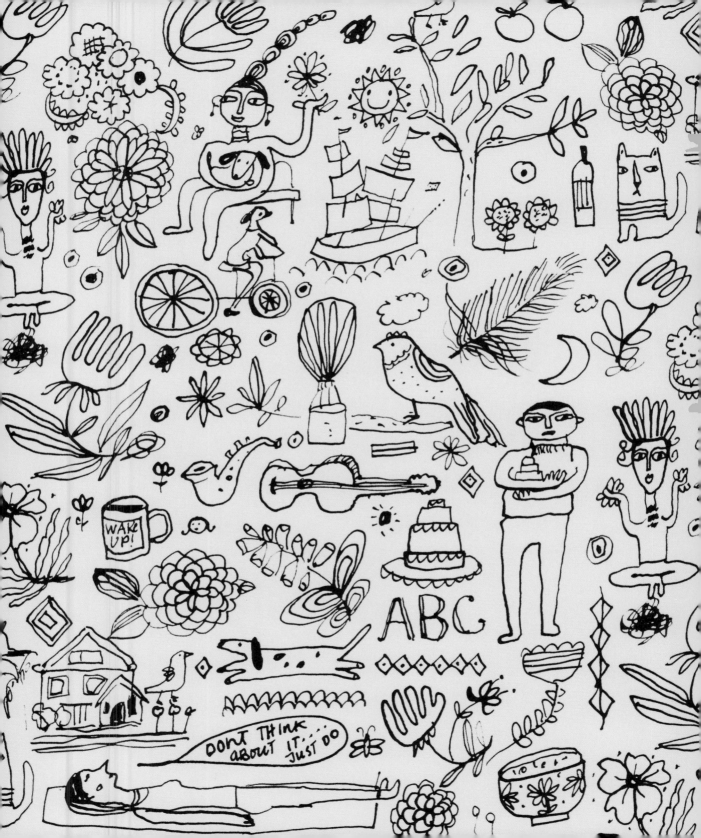

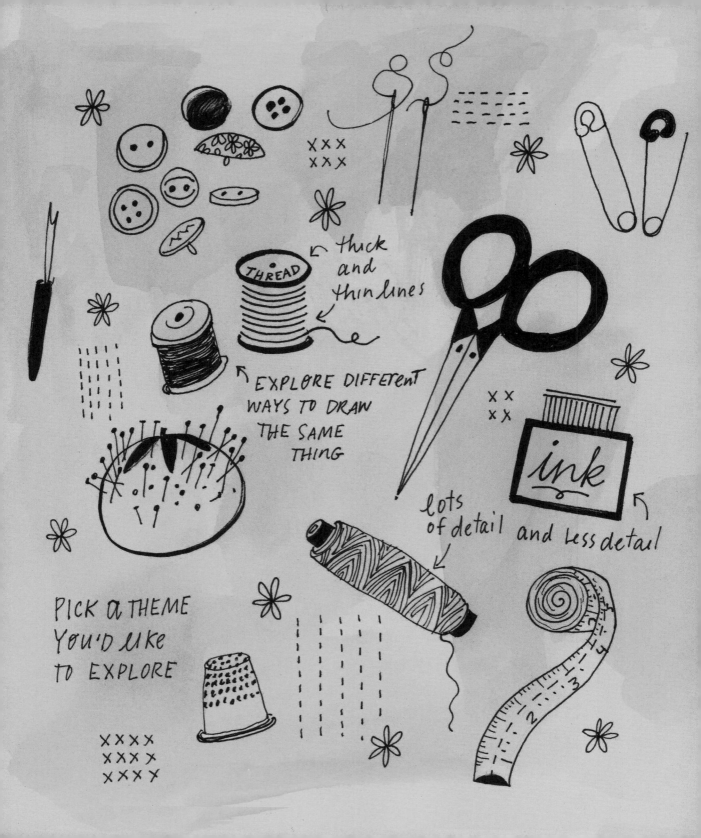

THREAD

thick and thin lines

EXPLORE DIFFERENT WAYS TO DRAW THE SAME THING

ink

lots of detail

and less detail

PICK a THEME YOU'D LIKE TO EXPLORE

DAY 9 ___/___/___

What are the tools of your trade? Draw them here.

DAY 10 __/__/__

Fill this page with the ingredients of your favorite meal. maybe include utensils and descriptive words.

Use this PAGE to doodle FOUR things that help you relax
(or any FOUR related things that come to mind).

DAY 12 __/__/__

Put on some music, listen to an audio book, or get on the phone with someone and doodle mindlessly while you talk and listen. Fill the whole page.

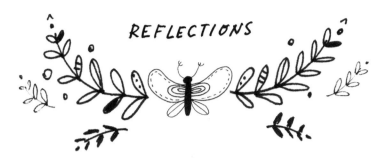

REFLECTIONS

It's interesting to see what comes out when you draw without thinking too much. What might help you get into the FLOW OF drawing, where you just have go with it and don't edit yourself?

DAILY DRAWING IDEA

MAKE DOT FACES

It's hard to get started on a face, so sometimes using a simple dot is a great place to begin. When I want to play around with expressions, I will paint multiple dots on the page in lots of different colors. Then I have my base, and it's easy to just start drawing the features. Try wide-set or wide-open eyes, a little round mouth or a very long, thin one. Each one will give you a completely different mood and style. To draw the hair, you can add some medium sized dots for a very curly style, curvy lines for long hair, or short strokes for a spiky look.

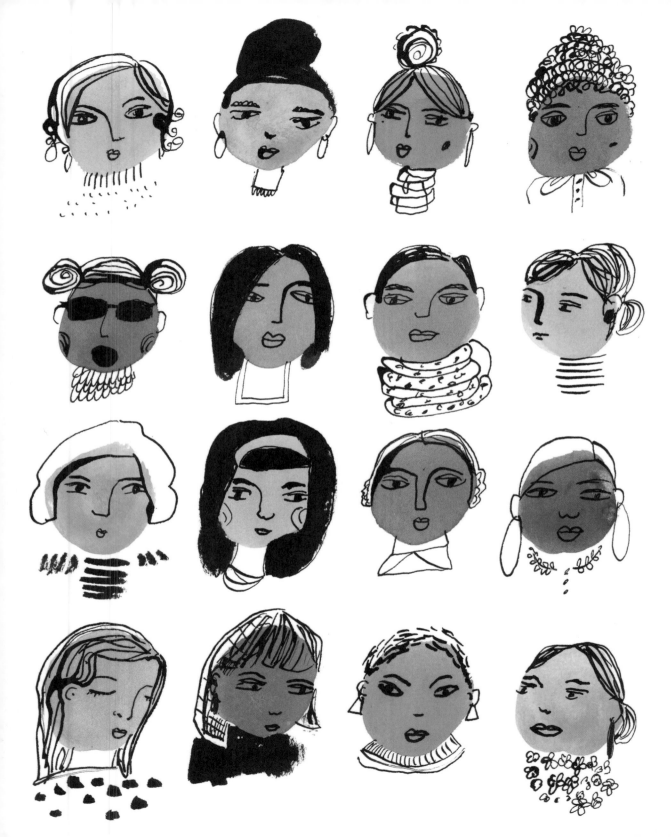

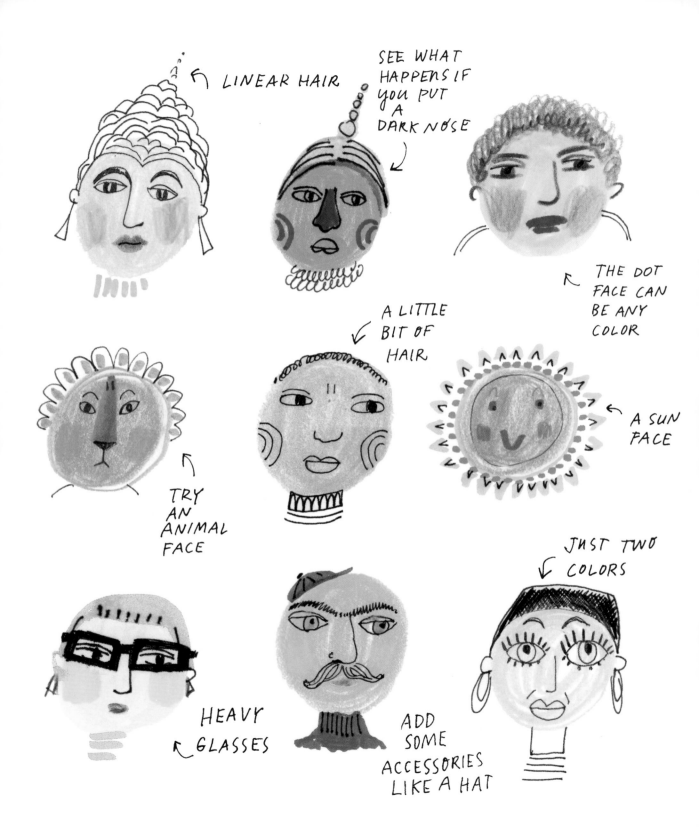

DAY 13 ___/___/___

start simple and draw faces on these dots with black pen.

MORE dots For various characters (But PerhaPs exPlore one color palette For all?).

THESE FOUR dots could become people in FOUR very different moods.

DAY 16 __/__/__

DRAW your own dots on this page, and turn them into faces—maybe one representing
you along with some close friends or family members (pets included!).

REFLECTIONS

TURN a dot into a FACE
that reflects your mood
right now, and jot down
what's on your mind.

DAILY DRAWING IDEA

SIMPLIFY HOUSES and BUILDINGS

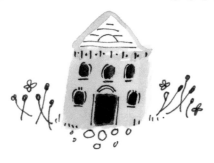

When I travel, I love to paint what I see: the museums, homes, stores, monuments, and other sites. There is so little time when I'm on the run, so learning to simplify these structures down to the basics is a necessity. Before I start drawing a building, I like to spend some time squinting at it to figure out what pieces are most important and what can be let go. I will sometimes start with a swath of color in the shape of the structure and draw the main features over that. Not every window needs to be represented.

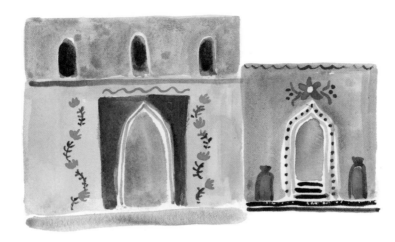

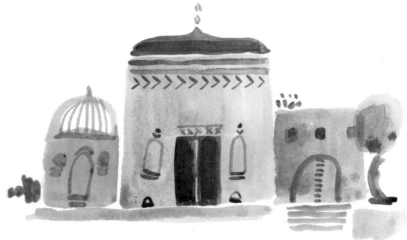

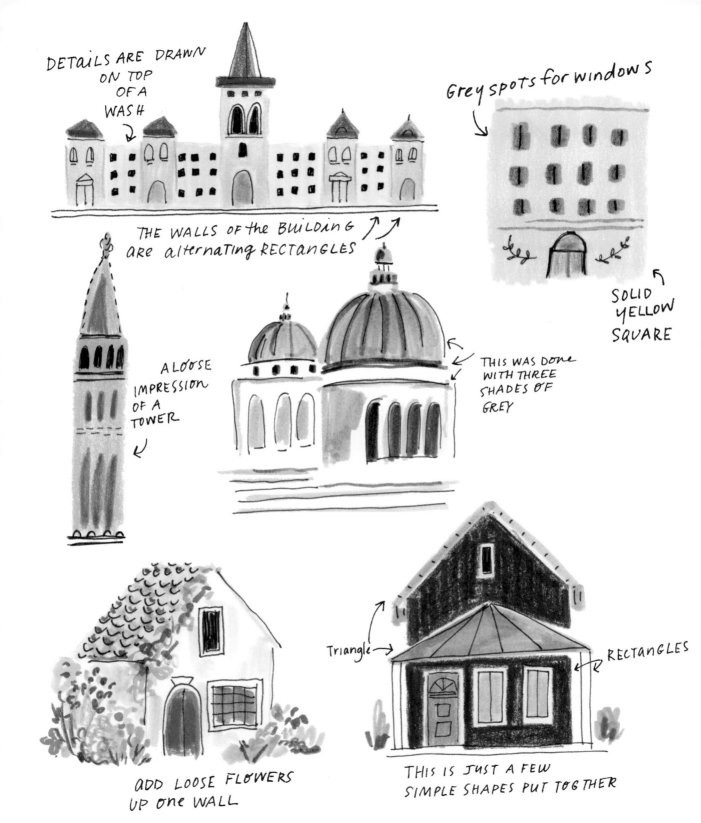

DETAILS ARE DRAWN ON TOP OF A WASH

Grey spots for windows

THE WALLS OF the BUILDING are alternating RECTANGLES

SOLID YELLOW SQUARE

A LOOSE IMPRESSION OF A TOWER

THIS WAS DONE WITH THREE SHADES OF GREY

ADD LOOSE FLOWERS UP ONE WALL

Triangle

RECTANGLES

THIS IS JUST A FEW SIMPLE SHAPES PUT TOGTHER

DAY 17 _/_/_

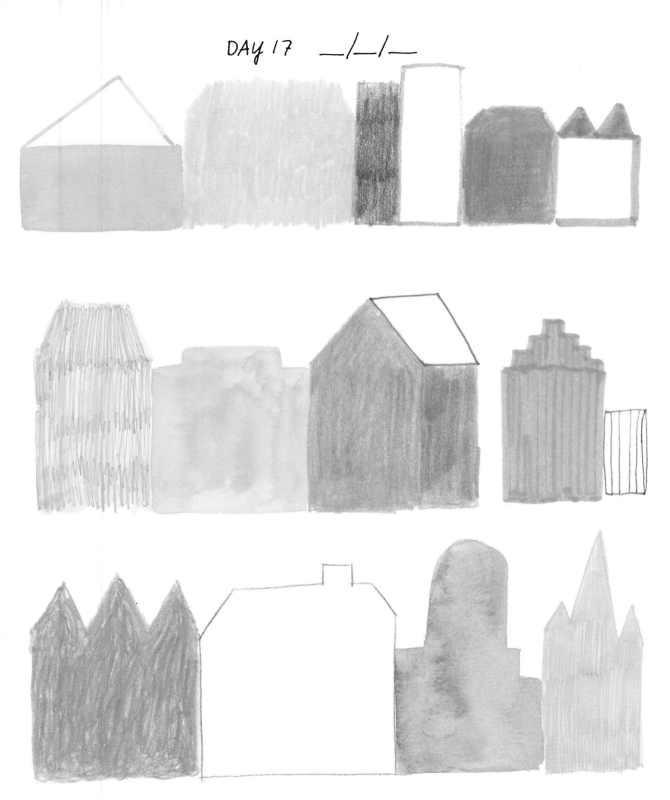

Add a variety of details to these simple shapes to make a neighborhood of row houses.

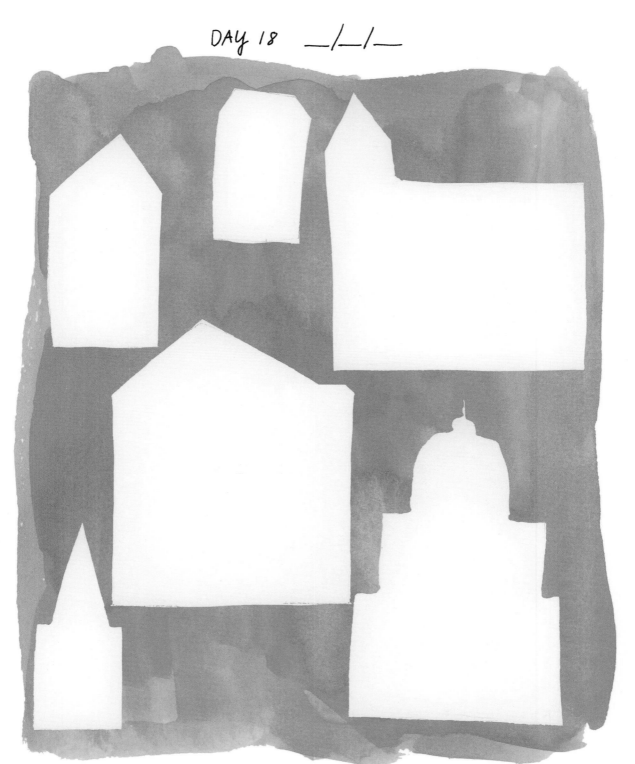

Fill in these various building shapes with architectural details. You could also label them and connect them with streets or paths to make the drawing look like a map.

DAY 19 _/_/_

Add detail to these shapes. Then draw a completely different version below it.

DRAW A SIMPLE VERSION OF THE BUILDING THAT YOU LIVE IN NOW.

NOW, DRAW A SIMPLE VERSION OF YOUR DREAM HOME.

REFLECTIONS

Make a point of walking around your neighborhood or town and pay attention to the architecture. Are there details that you appreciate? Jot down some buildings that you'd like to draw.

DOODLE in GEL PEN

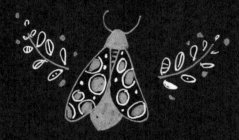

Doodling is perfect for just spilling your ideas out on the paper without overthinking. Since childhood, i've doodled flowers, birds, and squiggles on every bit of paper available, from schoolwork to notebooks, to pads by the phone, to newspapers. I absolutely love doodling with gold and white gel pen on black paper. The gold is so shiny and bright—it's like a bit of jewelry I can't stay away from. My doodles sometimes mix nature with kitchen utensils or cars and monsters. It's an open game.

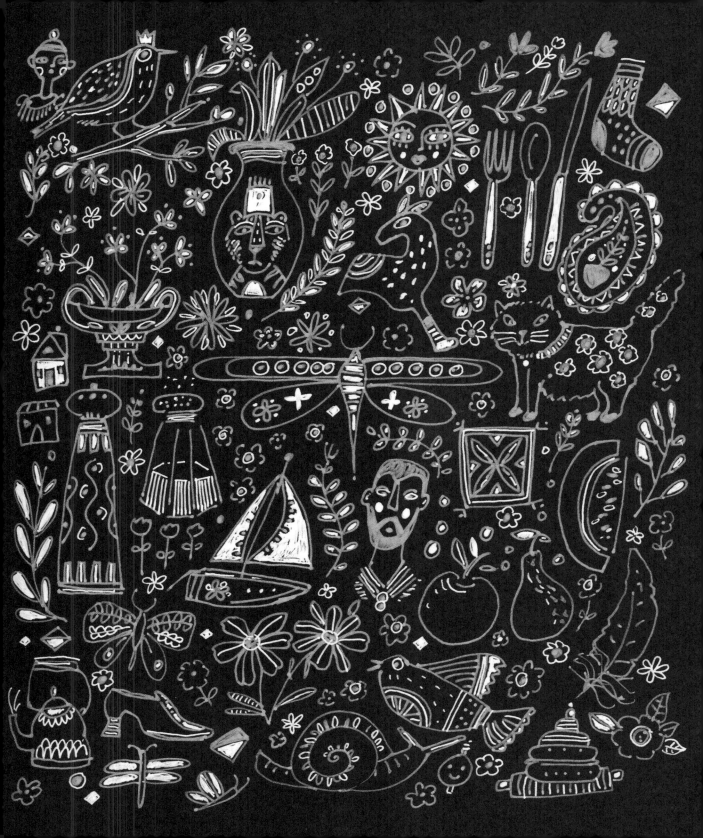

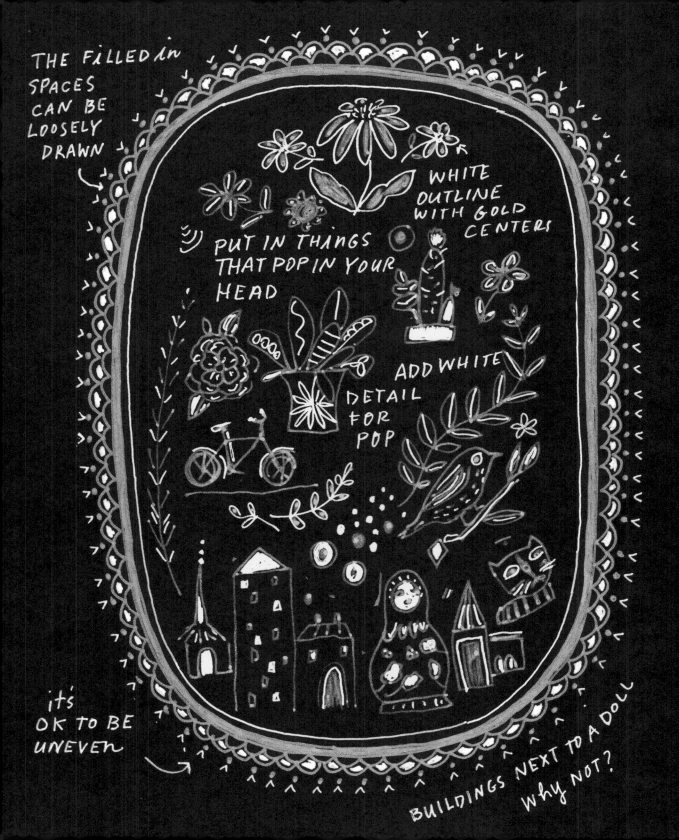

Fill this FRAME with gold and white doodles.

continue this mandala.

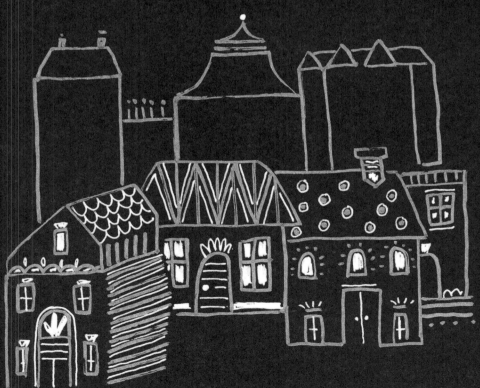

Build up this town with more houses.

DRAW FOUR things that are Precious to you in White and gold.

REFLECTIONS

Do you tend to doodle in meetings or in class or when you are on the phone? What do you like to draw, and do you think there's any significance to those drawings?

DAILY DRAWING IDEA

EXPLORE SHAPES OF LEAVES

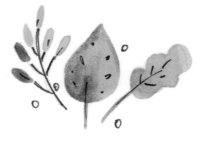

One way I get inspired is by taking a walk and picking up pretty bits of vegetation as I go. I get rejuvenated being out of the studio and in the fresh air. It's easy to draw a simple oval leaf, but when I take time to look closely, I'm fascinated by all of the different species and the way they grow from their stems. I like to collect a variety of leaves and make interesting compositions based on their shapes. Then I can take the drawing to another place by adding contrasting patterns and colors within the leaves.

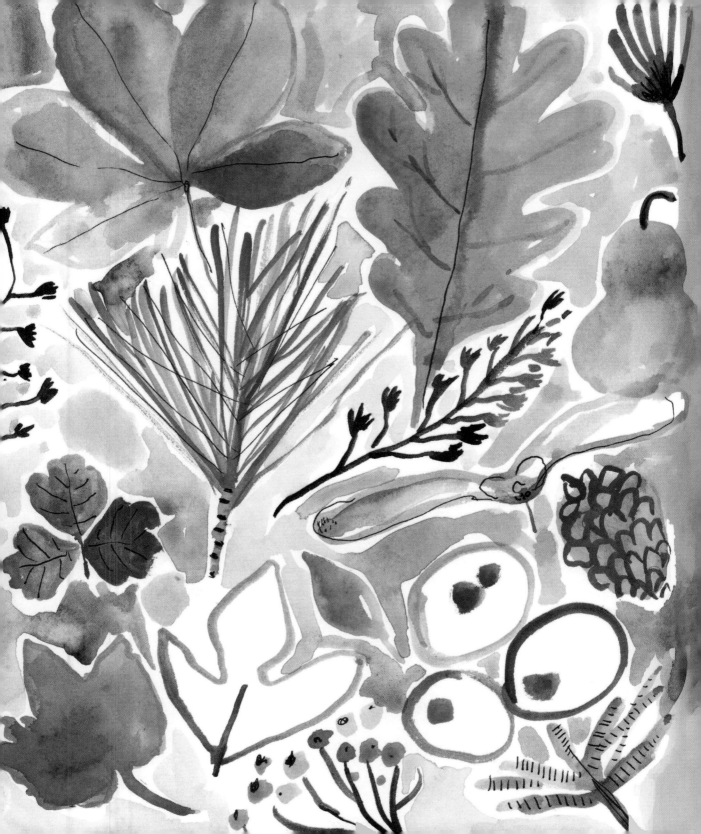

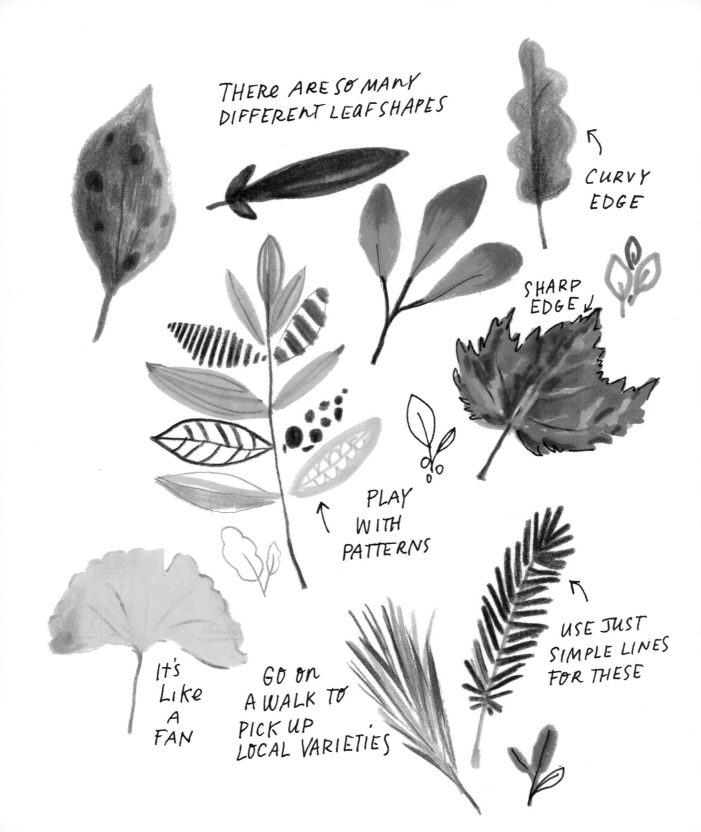

THERE ARE SO MANY
DIFFERENT LEAF SHAPES

CURVY
EDGE

SHARP
EDGE

PLAY
WITH
PATTERNS

It's
Like
A
FAN

GO On
A WALK TO
PICK UP
LOCAL VARIETIES

USE JUST
SIMPLE LINES
FOR THESE

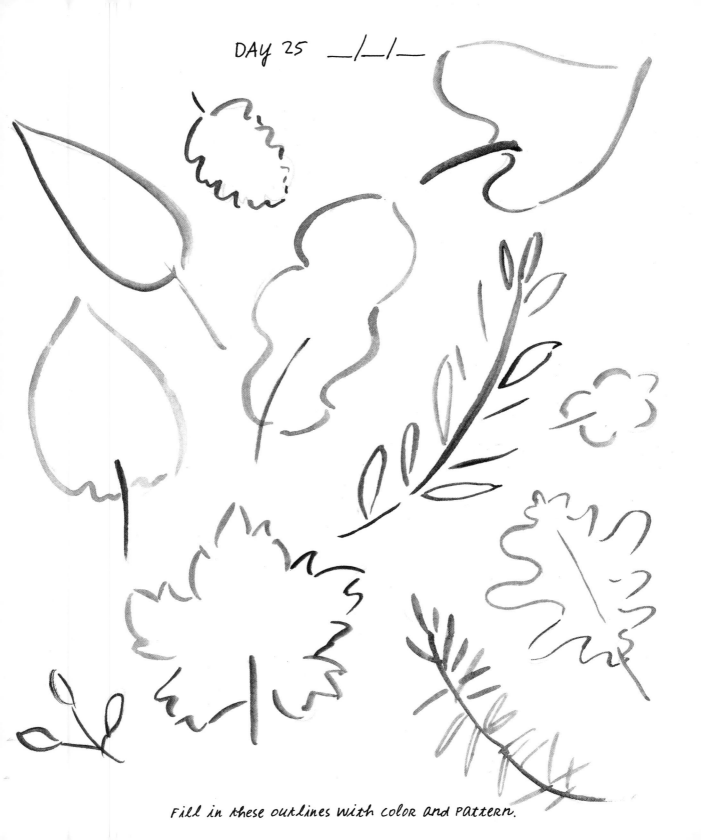

Fill in these outlines with color and pattern.

DAY 26 __/__/__

Collect four different leaves (or look up references) and draw them here.

choose one leaf shape that you love and draw it in repeat,
maybe make a pattern or a design out of it.

DAY 28 __/__/__

Fill this page with a drawing of one leaf, capturing its color, pattern, and texture.

REFLECTIONS

How much inspiration do you get from nature? Write a little bit about your relationship with the great outdoors.

DAILY DRAWING IDEA

DRAW FACES ON OBJECTS

Putting a face on an object makes it come alive! you can choose if it's happy or sad, surprised or scared, sleepy or just bored. Play with expressions, color, and lines. Absolutely anything can become a character: a sun, a spoon, a pencil, or a computer. I can make myself laugh while drawing faces on objects, which is the best way to spend some time!

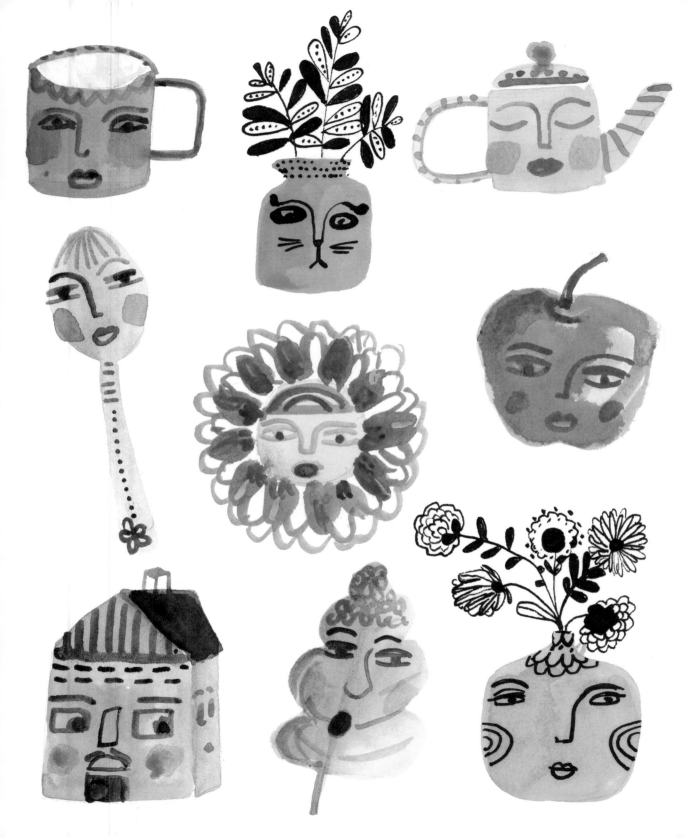

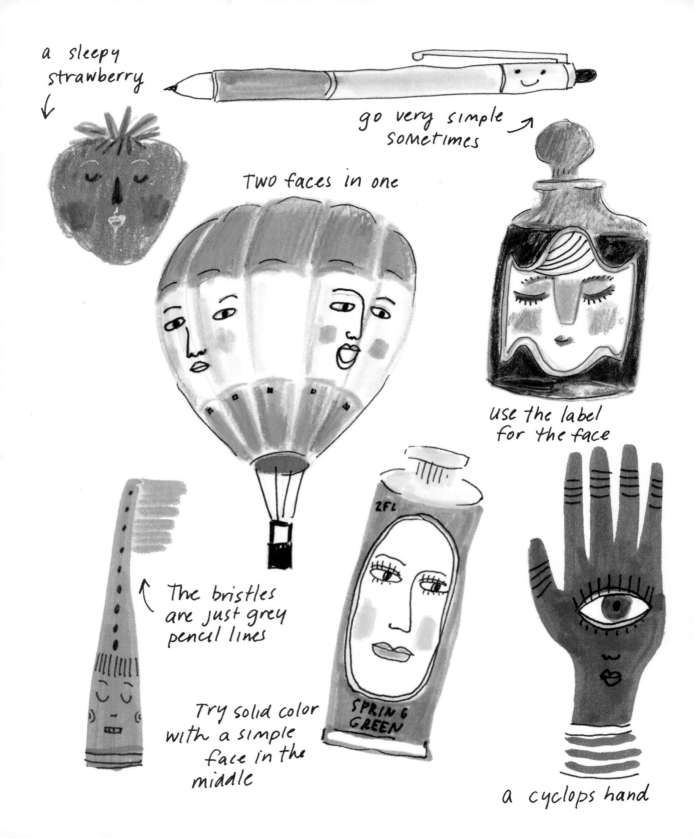

a sleepy strawberry ↓

go very simple sometimes →

Two faces in one

use the label for the face

The bristles are just grey pencil lines

Try solid color with a simple face in the middle

2 FL

SPRING GREEN

a cyclops hand

DAY 29 __/__/__

Use BLACK pen to draw faces and add detail to these objects.

Add color and Faces to bring these objects to life.

DAY 31 __/__/__

PICK FOUR OBJECTS that you use every day and give them a little PERSONALITY.

TRY dRAWING a comPLETE tea Set and give each oBJECt
an exPRession to Match its chaRACteR.

REFLECTIONS

Look around the room for a moment and focus on one object that "speaks" to you. Imagine this item coming to life and actually talking to you. What would it say?

EMBELLISH BUTTERFLY WINGS

There are so many reasons why I love to draw butterflies! They have such a great variety in the shapes of their wings, plus their symmetry gives you the chance to try the same design twice. Some butterflies have exquisite patterning in just two colors, and others feature intricate designs with stripes, dots, and oddball marks. There is even a species that looks like it has leopard spots. The wings give you the perfect, enclosed place to imagine any kind of design, so why not a face or a landscape?

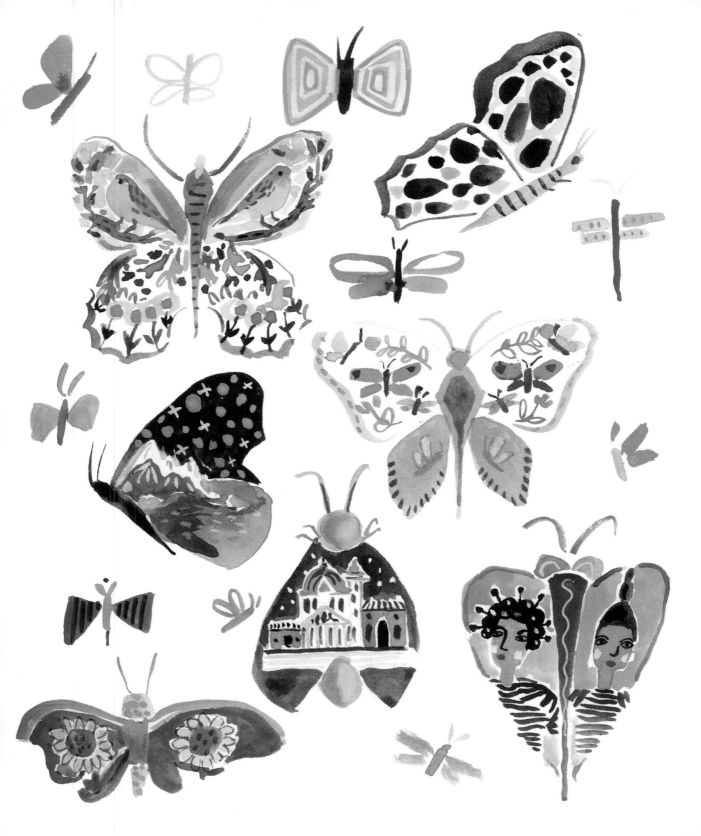

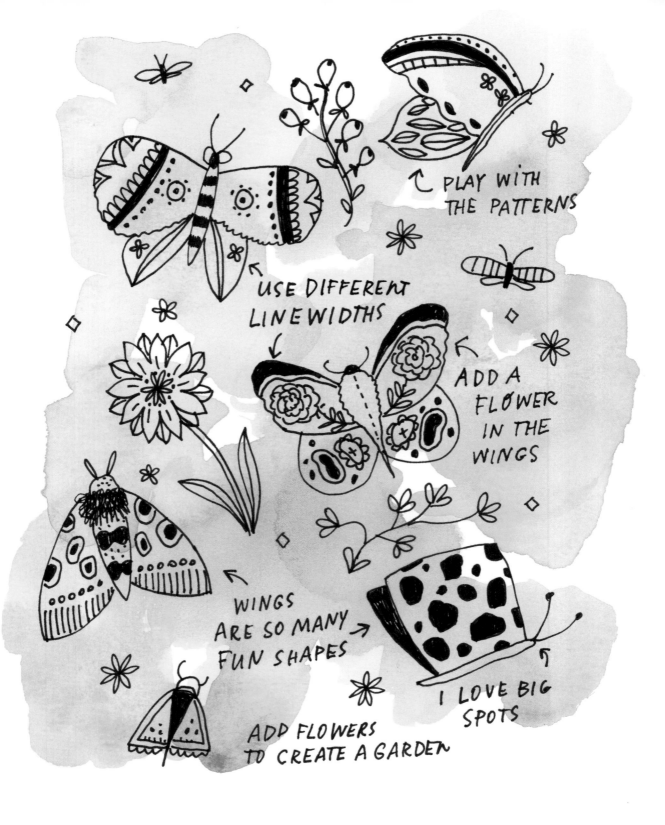

PLAY WITH THE PATTERNS

USE DIFFERENT LINE WIDTHS

ADD A FLOWER IN THE WINGS

WINGS ARE SO MANY FUN SHAPES

I LOVE BIG SPOTS

ADD FLOWERS TO CREATE A GARDEN

DAY 33 __/__/__

DRAW butterflies in black pen on this washy background.

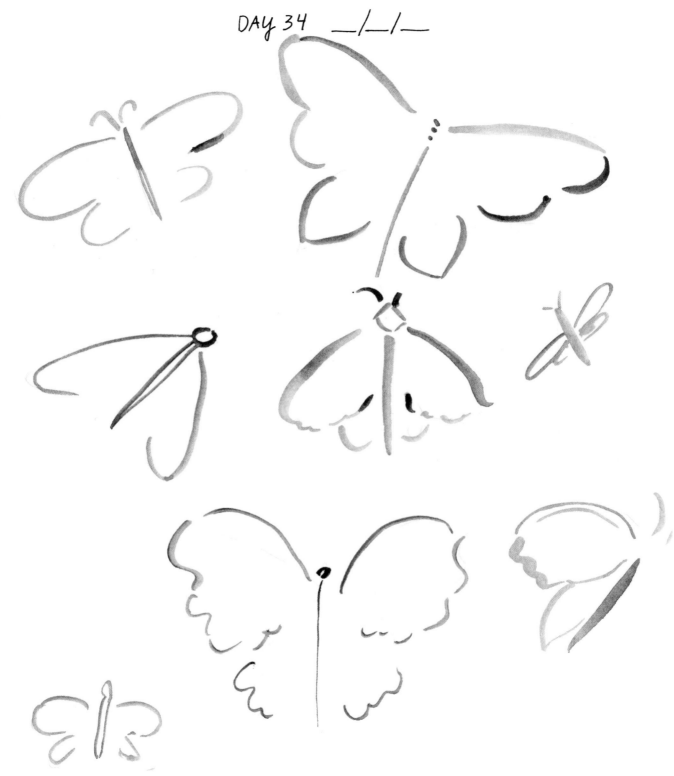

Decorate these wings.

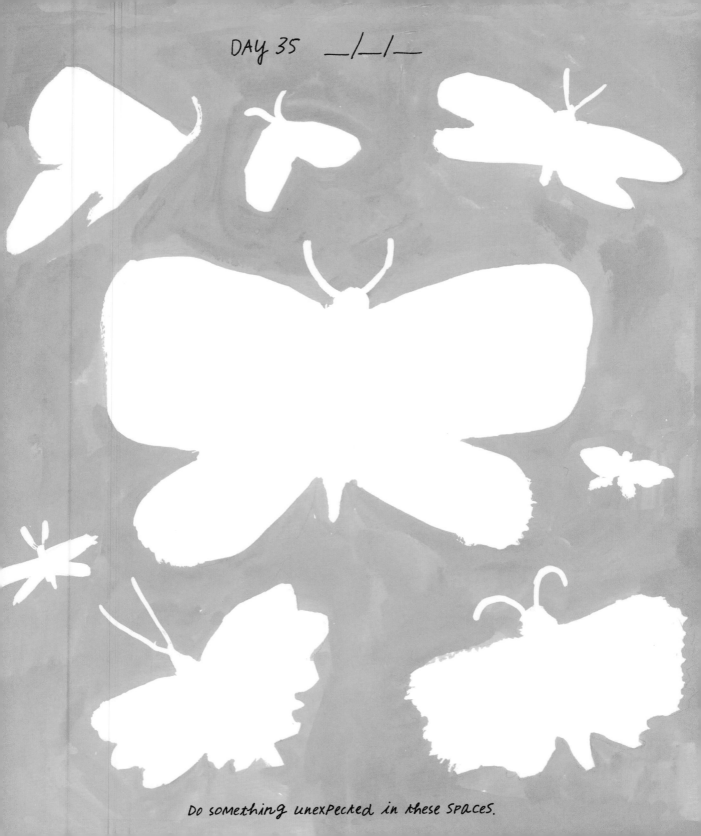

DAY 35 __/__/__

Do something unexpected in these spaces.

DAY 36 __/__/__

Fill this space with as many butterflies as you'd like.

REFLECTIONS

Butterflies are a symbol of transformation and change. Is there something you'd like to change right now? A career shift, a new project, an adventure, or an old habit to break? Take a moment to contemplate that change.

DAILY DRAWING IDEA

TRY HAND LETTERING

single letters can be a piece of art on their own. Putting them together can make a beautifully drawn word. you can FOCUS on the First letter of your name, or practice drawing an entire alphabet. Look at traditional Fonts FOR inspiration, or just COMPLETELY GO OFF on a tangent. TRY turning letters into animals! wonky looks great in this case.

LETTER IN
AN OBJECT

A
WIDE SHADOW

TRY A
VERY
SKINNY
LETTER

COLOR
AROUND THE
OUTSIDE

USE DIFFERENT
TEXTURES

LOOSELY
CIRCLE THE LETTER

TRY
ALTERNATING
COLORS

MAKE IT INTO
AN ANIMAL

CONTRASTING
COLORS

BOLD
GEOMETRIC
EMBELLISHMENT

COLOR IN
THE
NEGATIVE
SPACE

PUT LITTLE
DESIGNS ON
THE ENDS

V S e F u
L F
c O R
c J
i G J d
q T n M

Doodle on these letters. Add patterns and embellishments or turn them into animals.

DRAW YOUR MONOGRAM IN GOLD AND WHITE GEL PEN INSIDE THIS CARTOUCHE.

DAY 39 __/__/__

TRY lettering your Full name. you can do each letter in a
different style or Pick one approach.

DAY 40 __/__/__

create your own alphabet here.

REFLECTIONS

Do you like your name? If you had a choice, would you pick a different one or a different nickname? Reflect on this below (in your best penmanship, of course).

DAILY DRAWING IDEA

DRAW
a VARIETY OF FOOD

I come back to the subject of food often, because there is such a huge variety of things to draw in this category! Sushi alone has so many shapes and colors. I often snap photos of bakery displays, sandwich shops, and vegetable stands so that I have a large arsenal to reference and work from. The meals you cook and the cereal you pour are all great subjects. Remember to simplify! It's ok to not draw everything you see. You can lay down a block of color and draw a little detail on top, and the essence of the food still comes through.

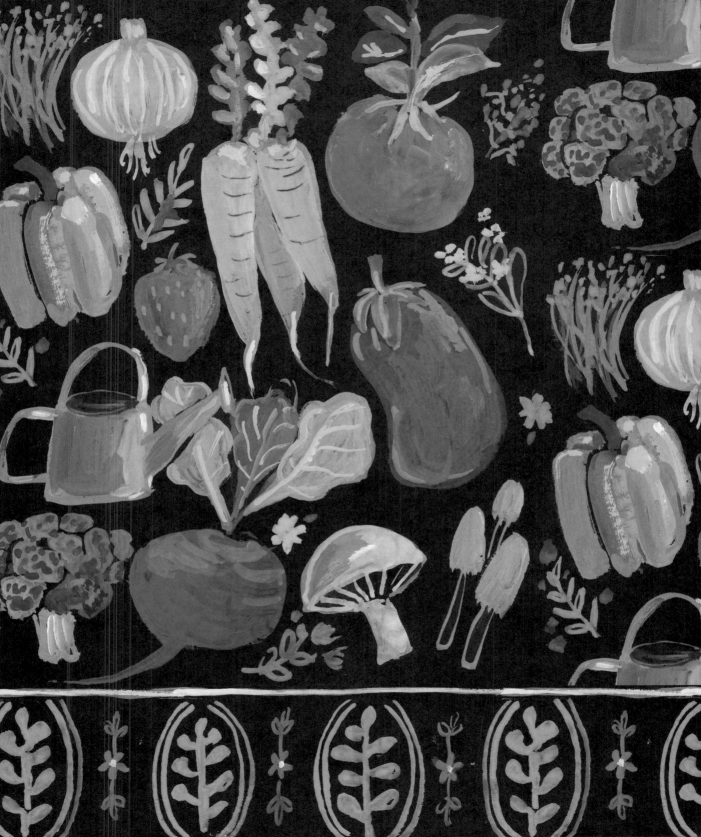

DARK AND LIGHT SHADES POP THE DRAWING

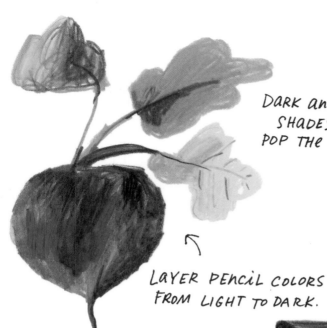

LAYER PENCIL COLORS FROM LIGHT TO DARK.

SIMPLE LINES EVOKE the FROSTING LAYERS

THE RICE IS JUST the color of THE PAPER with a FEW SPOTS OF GREY ↓

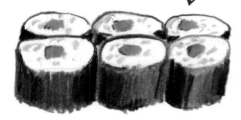

THE EDGES DON'T NEED TO BE a SHARP LINE

You can JUST MAKE a FEW BLOBS OF COLOR and DEFINE THE SHAPE with a BLACK LINE

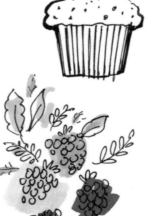

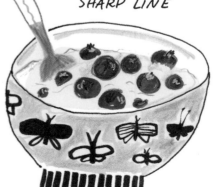

DAY 41 __/__/__

Use a black pen to doodle different types of food on top of these color washes.

DRAW something different on each plate.

DAY 43 __/__/__

on this Butcher paper Background, draw your favorite
Food items From the Farmers Market.

DAY 44 __/__/__

Use this page to draw whatever type of food appeals to you visually. Some striking ideas: rows of frosted donuts, foods that are all the same color, or different varieties of the same food.

REFLECTIONS

Are you an adventurous eater, or do you prefer to stick to the tried and true? Has your palette changed over time?

DAILY DRAWING IDEA

CREATE BEAUTIFUL TILE FLOORS

I always gasp when I see a gorgeous patterned floor, and I love to reinterpret it as a drawing. I don't bother copying it exactly. In fact, it's so enjoyable to take different tiles that inspire you and put them together to see what new pattern comes out. The trick is to add something just a bit unexpected. I will include a bird tile or a tile with a face to the mix for a little visual surprise. You might try putting an oddball color in the mix, too!

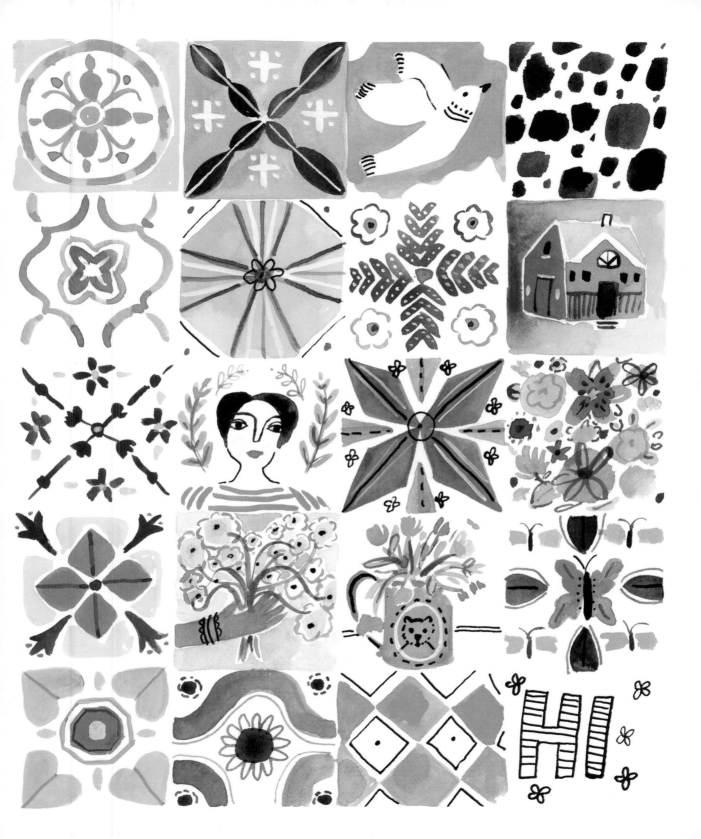

I MIXED COLORED PENCIL AND BLACK PEN →

WHY NOT JUST SCRIBBLE ↗

CLASSIC VS. VINTAGE ↘

←

SO GOOD

IT'S INTERESTING TO SEE WHAT HAPPENS WHEN YOU MIX ALL THE MEDIUMS. MARKERS, PENCILS, GELPEN, AND GRAPHITE ↓

put in WORDS THAT MAKE YOU FEEL GREAT!

OR AN ALLOVER PATTERN ←

↗

DAY 45 __/__/__

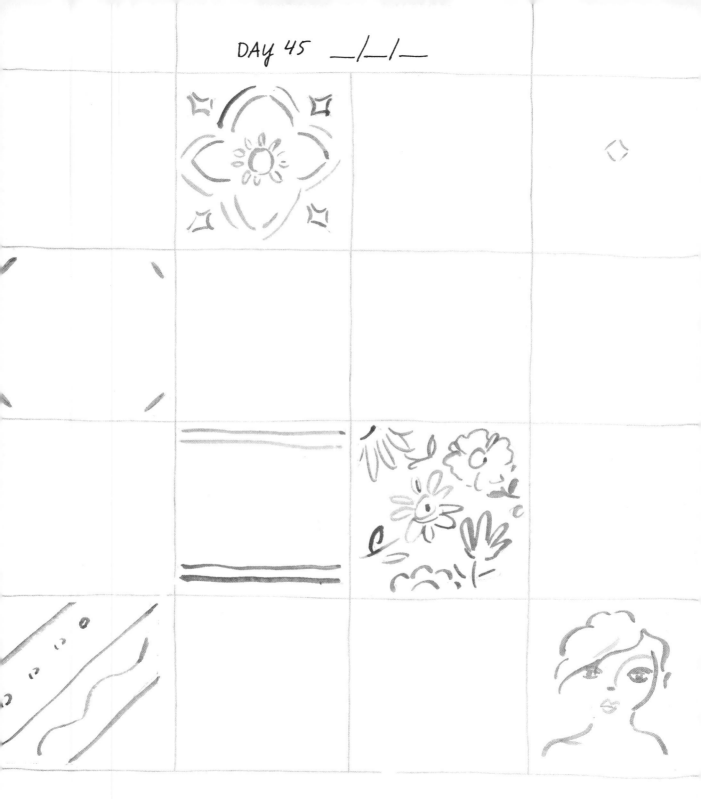

Finish this page by filling in the empty tiles with your own designs.

DAY 46 __/__/__

TURN these colored Blocks into tile designs, Perhaps For a Modern Kitchen.

DAY 47 __/__/__

MORE COLORED BLOCKS FOR YOUR tile deSignS. MAYBE these are FOR a COUNTRY Kitchen.

Design a collection of tiles. A common color scheme could tie various designs together (but try throwing in an odd color for fun).

REFLECTIONS

In general, are you attracted to a lot of different colors and patterns? or do you prefer a more minimalist aesthetic? What (or who) has influenced your taste?

DAILY DRAWING IDEA

RECORD YOUR DAY

When I'm feeling uninspired, drawing a timeline of what I've done so far with my day is a great solution. A representation of your day doesn't need to be linear. Maybe you just capture the moments that were significant. I might focus on a theme, like "Where I Went Today," and record driving to the supermarket, going to the dentist, and then out for an afternoon walk. If you did this activity every day, you'd have an amazing visual diary of how you spend your time. Adding a little text helps to complete the story.

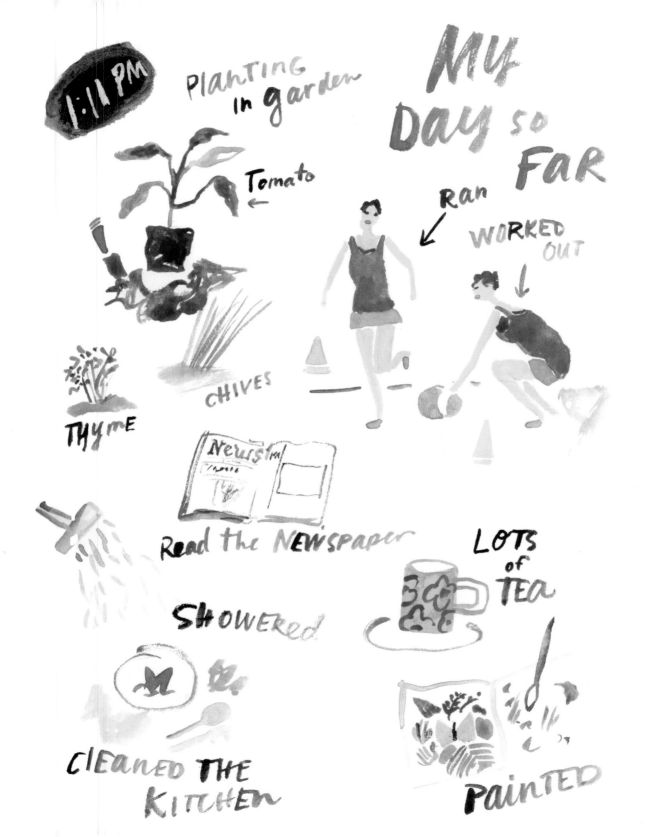

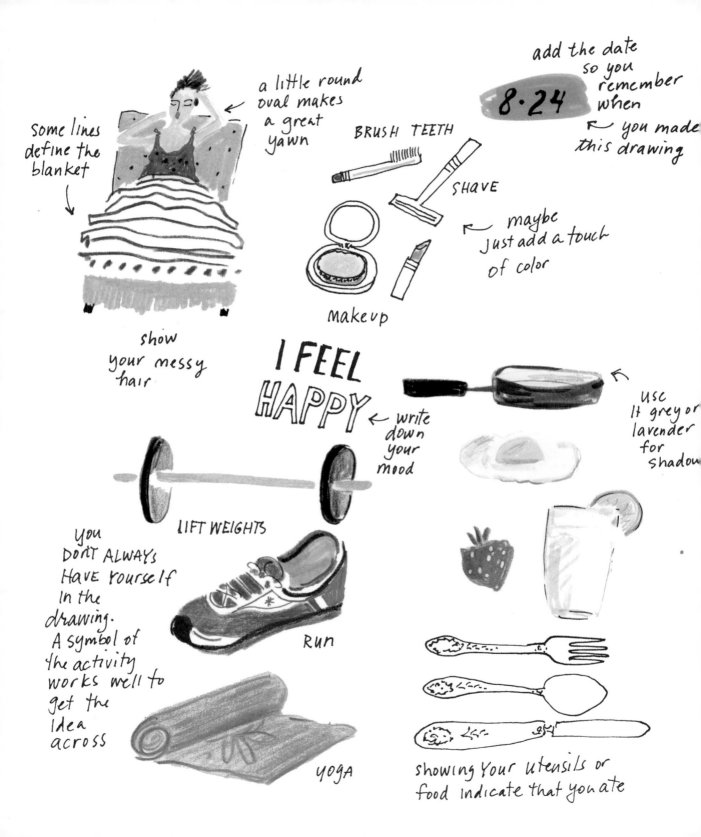

DAY 49 __/__/__

Fill in this page with objects representing different parts of your day.

When I woke up.

What I wore.

What I had to eat.

Number of glasses of water I drank.

The highlight of my day.

My mood right now.

DAY 50 __/__/__

Use Black Pen on this colorful Background, and
document Some OF the things that you did today.

DAY 51 __/__/__

What I'm watching now.

My favorite accessory.

The weather today.

Food I'm craving.

I can't live without . . .

Quote of the day.

DAY 52 __/__/__

PerhAps use this PAGe to dePict your idea of a PerFect day;
a Weekend day or a vacation or a FAntastic day at Work.

REFLECTIONS

ok, take a break from making a visual diary, and write about your day. Describe one highlight, one challenge, and one thing you're grateful for.

DAILY DRAWING IDEA

USE ONLY BLUE AND WHITE

I do this a lot and I love it! Blue and white is a classic and sharp-looking combination. It makes me think of Chinese pottery, delft tiles, and beach house décor. Your subject can be absolutely anything, though—you don't need to confine yourself to drawing blue and white objects! Use one shade of blue to make a simple and stylized drawing, or layer tones of blue to create depth and variety. Using shades of blue from dark to light will keep the page moving.

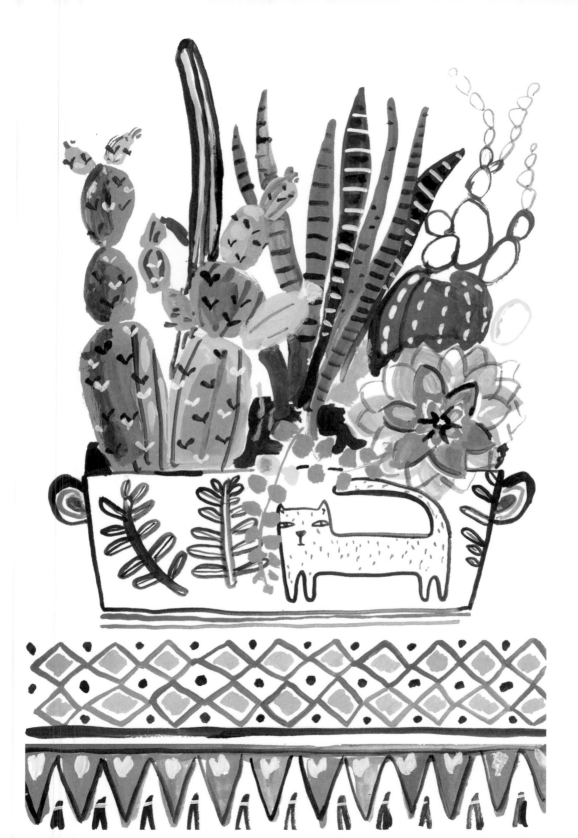

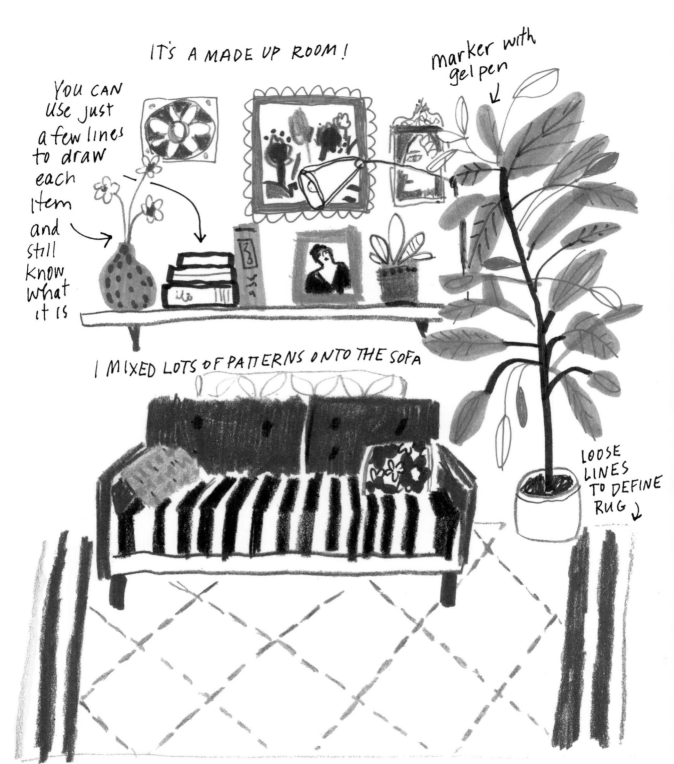

DAY 53 __/__/__

DRAW some Blue and White designs on these dishes.

DAY 54 __/__/__

Find a blue and white object and draw it on this page.

Find something that isn't Blue and White, But draw it using only those colors here.

DRAW on this Mid-toned Blue BackGround With darker Blue and White Pencils
(or darker Blue Water-BaSed Marker and Gel Pen).

REFLECTIONS

What comes to mind when you think of the color blue? Do you have any favorite blue things or blue-related memories? Take a moment to free-associate.

DAILY DRAWING IDEA

USE TWO COLORS PLUS A NEUTRAL

Using a neutral color such as a grey or a sandy color in the drawing really helps to tone things down and give a sense a calm. A neutral also helps a vibrant color really sing! I love to play with just three colors to see how they affect each other. You can make little swatches at the edge of your paper to work out the combinations before plunging in to your drawing. I tend to jump right in; if I don't end up loving the effect, at least I've learned something. The next day I will give another color combination a try.

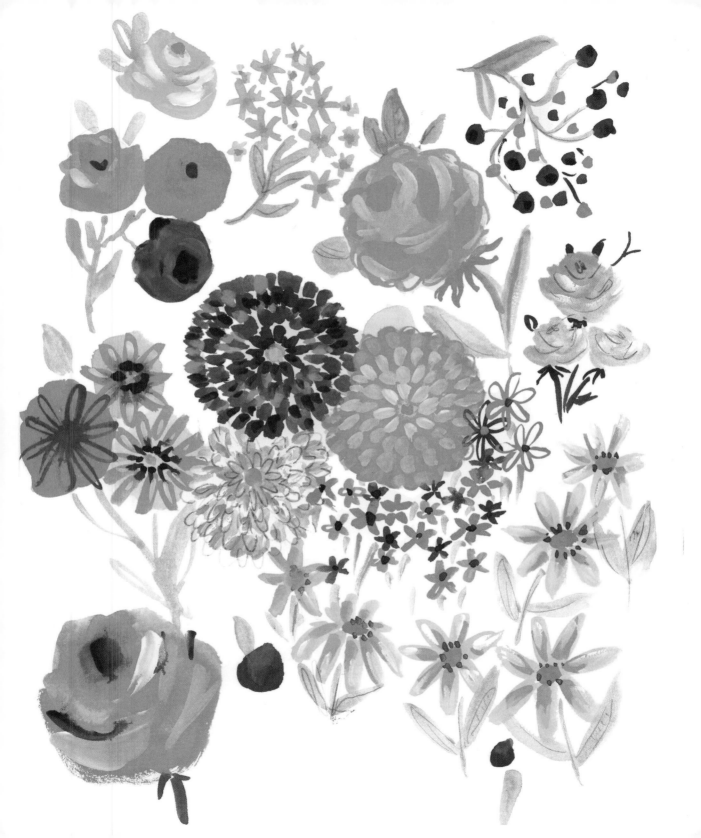

TRY OUT A FEW DIFFERENT COLOR COMBINATIONS.
I CHOSE THIS PALETTE FOR MY DRAWING BELOW.

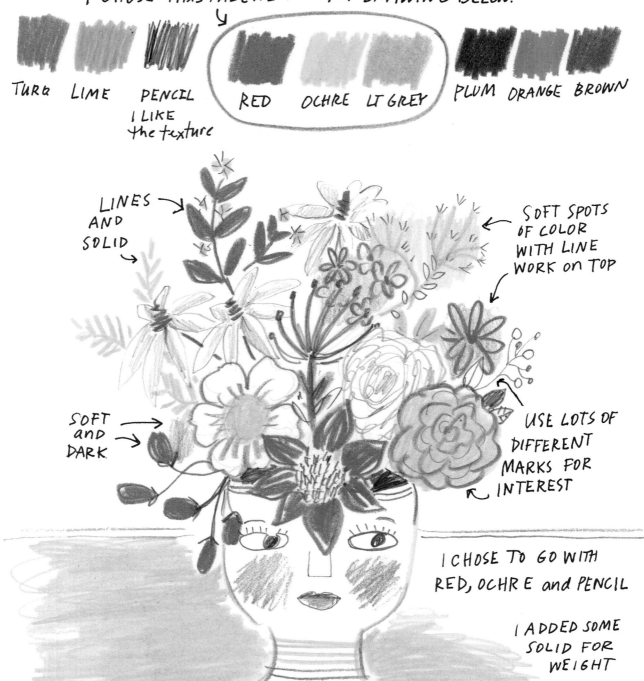

TURQ LIME PENCIL
I LIKE
the texture

RED OCHRE LT GREY

PLUM ORANGE BROWN

LINES
AND
SOLID

SOFT SPOTS
OF COLOR
WITH LINE
WORK ON TOP

SOFT
AND
DARK

USE LOTS OF
DIFFERENT
MARKS FOR
INTEREST

I CHOSE TO GO WITH
RED, OCHRE and PENCIL

I ADDED SOME
SOLID FOR
WEIGHT

DAY 57 ___/___/___

Fill in the items on this page using two colors and a neutral color.

make these glass vessels into terrariums or aquariums
by filling them with plants or fish, using just three colors.

DAY 59 ___/___/___

Make Four little drawings using the same three colors.

DAY 60 _/_/_

Pick two colors and a neutral and draw some objects that you've used today using only those colors.

REFLECTIONS

What are your Favorite color combinations to wear?
To decorate with?

DAILY DRAWING IDEA

DRAW A WILD HEADDRESS

This is a favorite theme of mine—imagine Frida Kahlo and Carmen Miranda gone wild! I might begin with a woman's head and then add flowers, birds, and bugs, and create an entire nest. You can build a super tall headdress or add some vines that end up surrounding the entire face. Maybe a little rabbit could pop out from behind a leaf. If you are tired of drawing flowers, you could go with a celestial or food theme. A dream you recently had could be a kicking off point for an amazing fantasy topper!

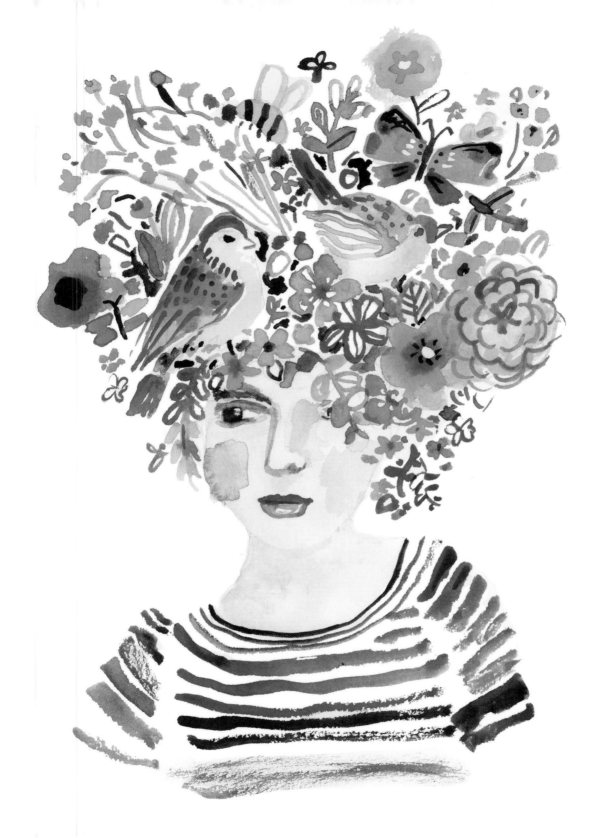

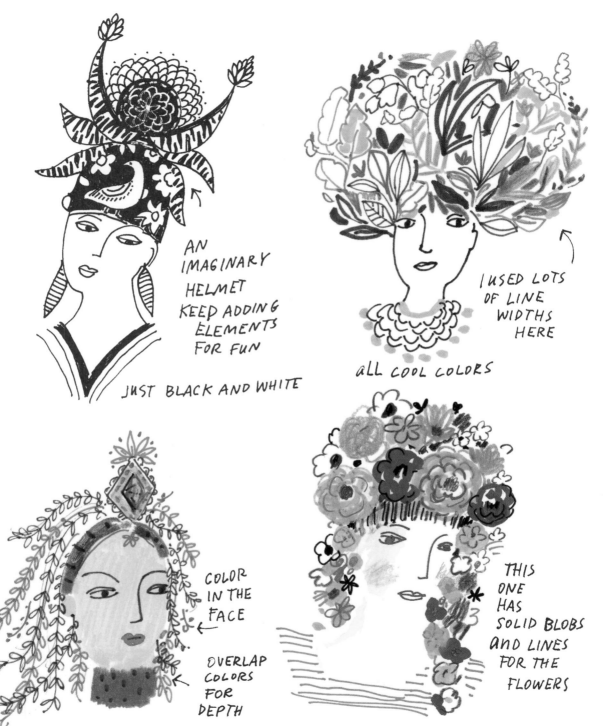

AN
IMAGINARY
HELMET
KEEP ADDING
ELEMENTS
FOR FUN

JUST BLACK AND WHITE

I USED LOTS
OF LINE
WIDTHS
HERE

all COOL COLORS

COLOR
IN THE
FACE

OVERLAP
COLORS
FOR
DEPTH

THIS
ONE
HAS
SOLID BLOBS
AND LINES
FOR THE
FLOWERS

all warm COLORS

Finish the headdress on this lady.

Design headdresses for these sisters. Are they alike or very different?

DAY 63 __/__/__

DRAW headdresses FOR FOUR queens.

Queen OF the night sky

Queen OF the BUTTERFLIES

Queen OF the jungle

Queen OF the deep sea

DAY 64 __/__/__

TRY a portrait of yourself wearing a fantastic headdress.
How does it represent who you are?

REFLECTIONS

What is on your mind? If a headdress spontaneously appeared on your head, representing the things that are important to you right now, what would it look like?

DAILY DRAWING IDEA

FOCUS on INSPIRING WORDS

: CREATE :

At times a single word can be great motivation to stay focused and inspired. I will choose a word for the day and then surround it with lots of detailed drawing. If I hang it up in front of my workspace, i'll see it more often and remember how I want to approach my work. Even just looking at the word "hope" while I draw around it puts me in a better frame of mind.

USE LOTS OF LAYERING FOR INTEREST

CREATE

 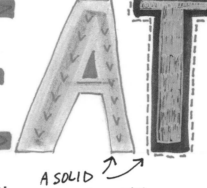 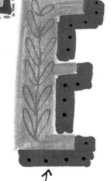

↑
MARKER
BASE WITH
PENCIL
LINES

↑
I LOVE TO
FILL IN THE
SPACES WITH
COLOR

↑
GEL
PEN ON
SOLID
MARKER

↰
A SOLID
OUTLINE LOOKS
DIFFERENT FROM A
DASHED ONE

↑
TRY A
CONTRASTING
COLOR TO SEE
WHAT HAPPENS

EXPERIMENT

PLAY WITH
TEXTURES and
COLORS
and
LAYERING

PLAY

THE WORD CREATE MADE ME THINK OF EXPERIMENTATION SO I
SPENT TIME USING THE ART SUPPLIES I HAD TO SEE WHAT
COULD HAPPEN.

A word that makes you smile.

DAY 66 __/__/__

A word that empowers you.

A word that grounds you.

DAY 68 __/__/__

REFLECTIONS

Look back at the words that you've chosen for this section. Pick one word that means a lot you to you. Why is it important?

DAILY DRAWING IDEA

CREATE ARTFUL TABLE SETTINGS

I get inspired by tables that are set with a placemat or tablecloth that contrasts with the pattern on the plates and glasses. Try playing with perspective; showing the top view of a plate and the side view of a glass makes your drawing a little wonky and fun. You can add a big bunch of flowers or a candelabra as a centerpiece. A casual meal can be so different than a fancy dinner, so there are endless combinations.

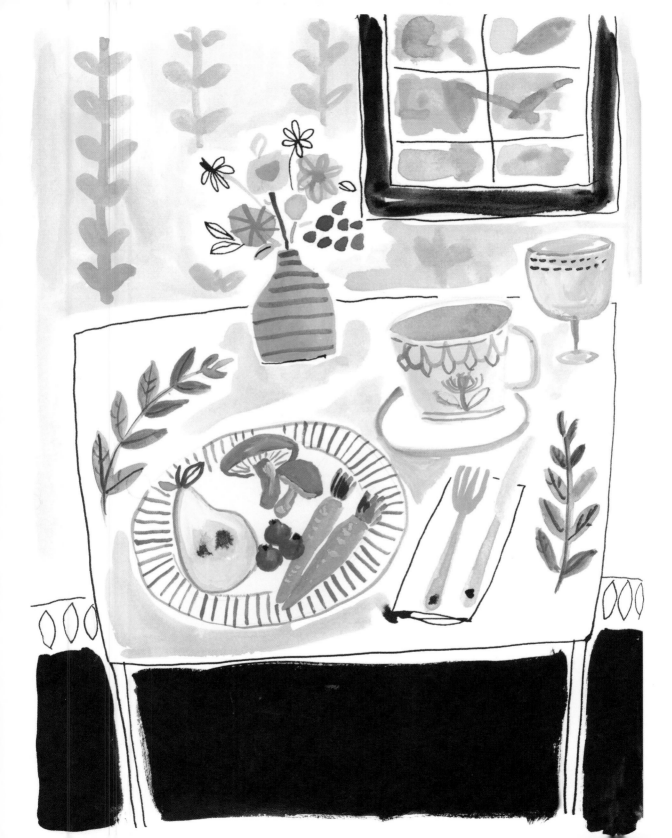

patterned tablecloth

add some decorated plates

Black pen detail

Same color combinations done ↑ very differently

no tablecloth

just a touch of another color

a floral table runner

pencil detail

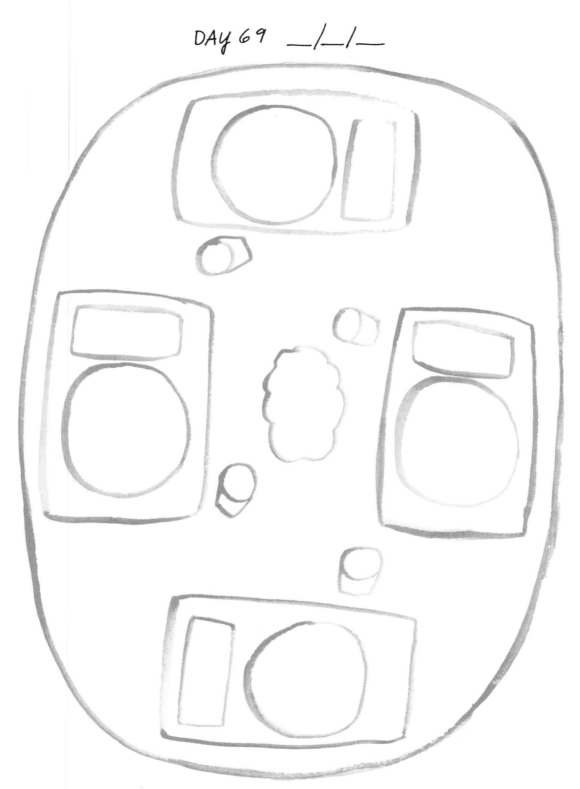

Add two designs to this table setting.

DAY 70 __/__/__

DRAW a place setting of your own from above.

NOW try it from a different angle.

DAY 71 __/__/__

TRY A diFFerent type of tABletop; MAYBe your deSk OR the ↑OP OF your dResser.

DAY 72 __/__/__

CReate a PLace setting for a character (imaginary or Fictional) of your choice.

REFLECTIONS

How do you set the table for a special meal? Do you have a special set of linens and dishes for the holidays?

DAILY DRAWING IDEA

DRAW TINY PEOPLE

DRAWING PEOPLE in a tiny scale makes me simplify the forms down to their most basic. I can't fit too much into a tiny pair of pants! It's very satisfying to capture someone's posture using just a few spots of color. I generally use reference photos for this exercise. I look at the gestures that people make, and try to create movement in my marks. A stroke or two can become the legs and another small shape becomes the torso. It's fun to change up the colors and create outfits from your imagination.

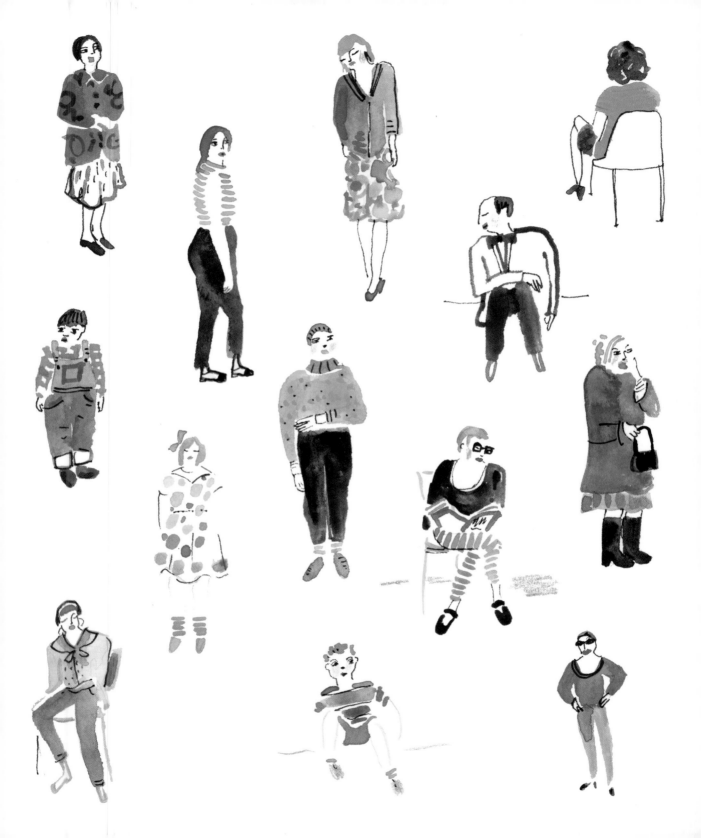

MARKER

BLACK PEN

COLOR PENCIL

PENCIL

MAKE SIMPLE SHAPES FOR EACH PIECE OF CLOTHING

DEFINE THE BODY PARTLY WITH AN OUTLINE

USE DIFFERENT PEN WIDTHS

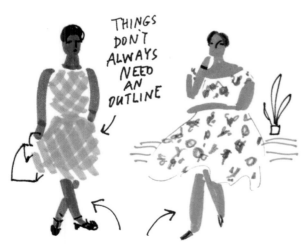

THINGS DON'T ALWAYS NEED AN OUTLINE

I JUST USED LINES FOR THEIR LIMBS

I USED 1 COLOR GEL PEN AND CREATED A BACKGROUND

IF YOU ARE NERVOUS ABOUT DRAWING A FACE, DRAW SOMEONE FROM BEHIND

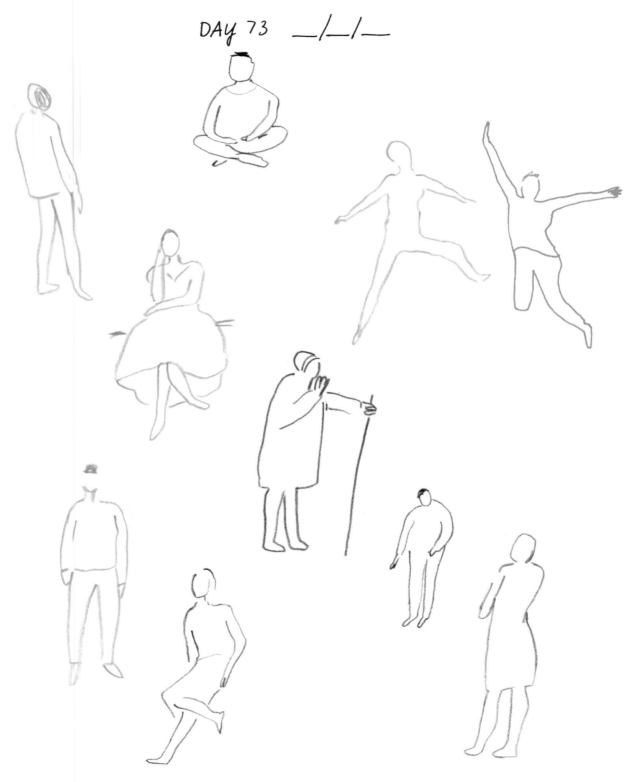

Add clothes, hair, and other details to these gestures.

DAY 74 __/__/__

DRAW SOME PEOPLE AT THE BEACH USING BLACK AND WHITE PENCIL.

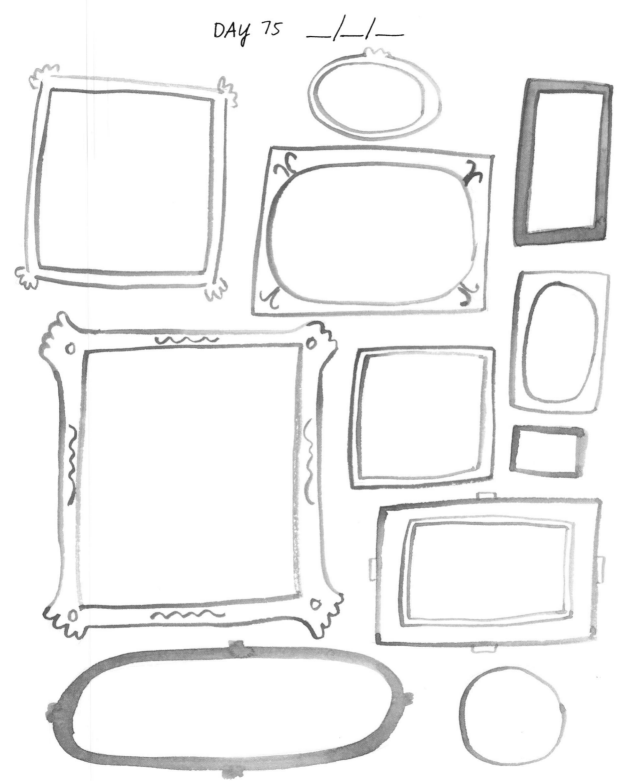

POPULATE THIS PAGE WITH little PORTRAITS OF PEOPLE YOU KNOW.

DAY 76 __/__/__

TRY going to a public place, and make little drawings of the people you see there.

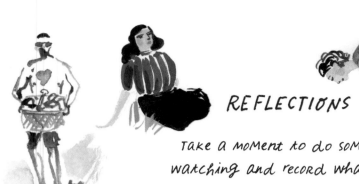

REFLECTIONS

Take a moment to do some people watching and record what you see.

DAILY DRAWING IDEA

PAIR BLACK and WHITE VASES WITH PLANTS

I love the contrast of a black-and-white vase with dense, colorful foliage. My vases range from basic striped vessels to animal-shaped containers bearing lush gardens. When I draw a plant that appears to be one shade of green, I still like to introduce other greens and blues to add interest. The patterning on my leaves might follow the veins and coloring of the actual leaf, or I might go for something abstract and simplified. Greens look great with a touch of hot pink or orange, so bits of stray color can really pop in the drawing!

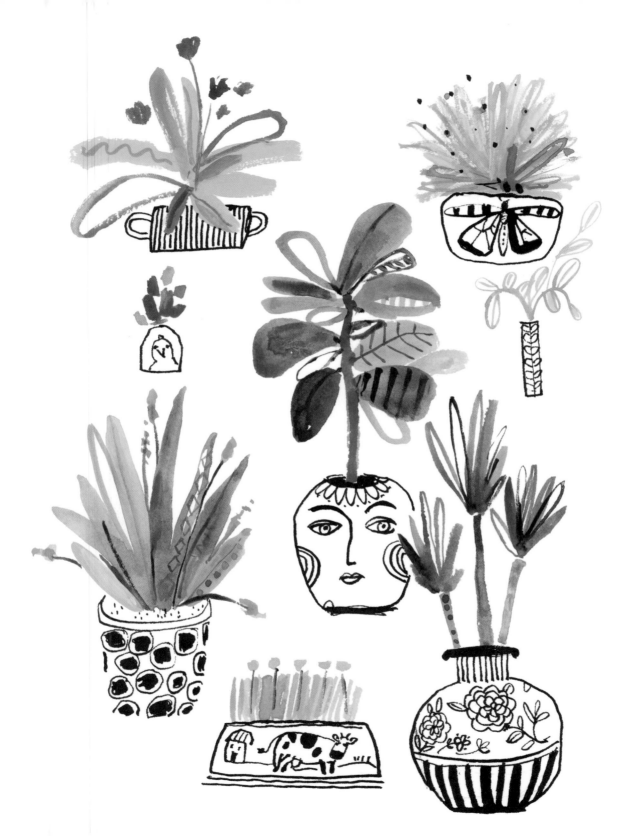

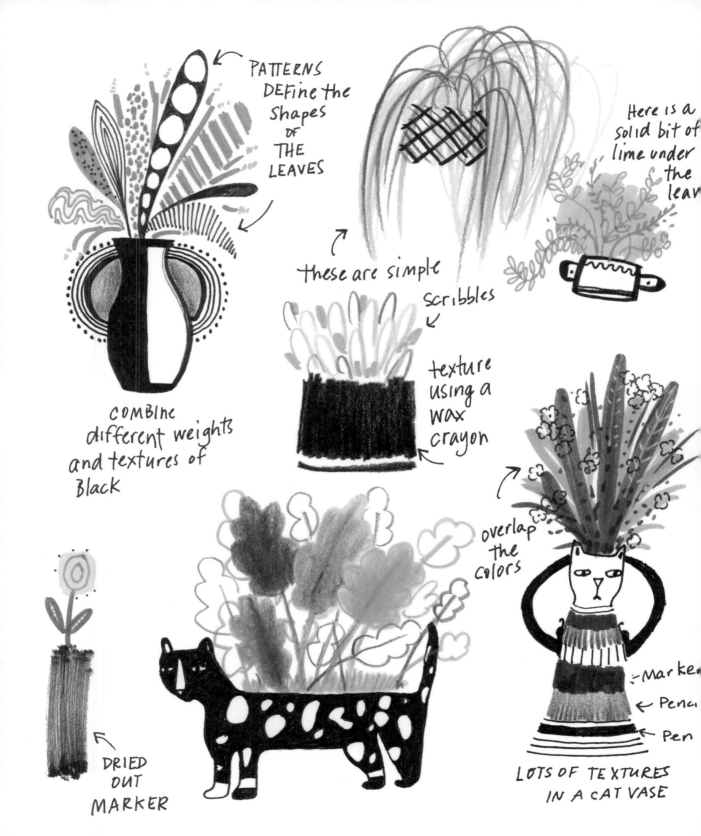

PATTERNS DEFine the Shapes OF THE LEAVES

COMBINE different weights and textures of Black

Here is a solid bit of lime under the leav

these are simple Scribbles

texture using a wax crayon

overlap the colors

DRIED OUT MARKER

Marke
Penc
Pen

LOTS OF TEXTURES IN A CAT VASE

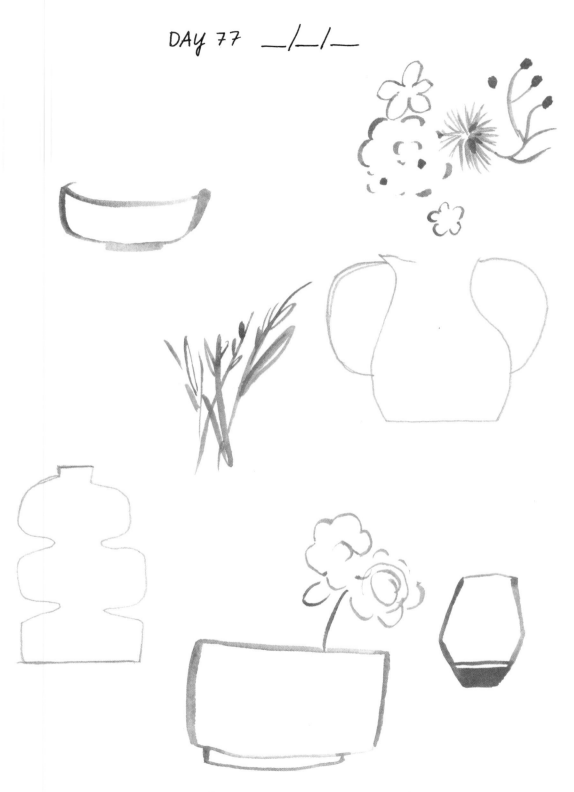

DRAW PLANTS in POTS and POTS FOR the PLANTS.

DAY 78 __/__/__

DRAW a caricature of yourself in this Planter and add Plants
that suit your Personality.

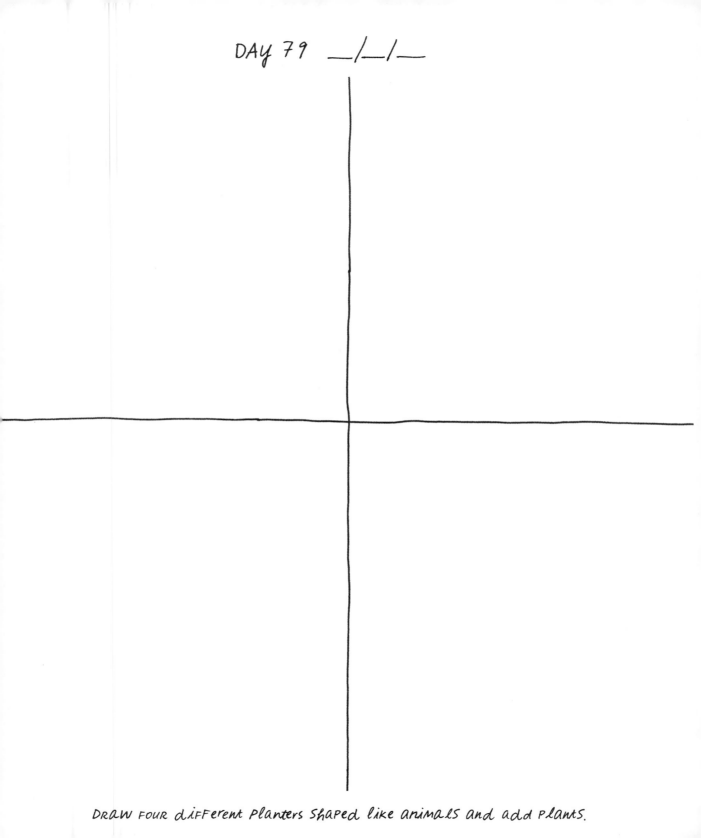

DRAW FOUR diFFerent Planters shaped like animals and add plants.

DAY 80 __/__/__

Imagine some unlikely planters, like a bathtub, a wagon, or a helmet, and fill them with plants.

REFLECTIONS

What did you find more fun to draw: the plants or the vessels? Why do you think that is?

DAILY DRAWING IDEA

COPY OLD PHOTOS

 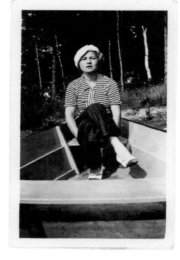

I adore old Photos. I have Boxes and Boxes of Family Photo albums from my childhood and my parent's childhoods. I also Buy anonymous ones from tag sales and antique stores. It's a treat to stumble on one that really speaks to me. I seek out Black-and-white photos where people are active, like dancing or playing music. I love looking at the people and imagining the color of their clothes, what their stories were, and the Places they visited. you can Bring these characters to life in your drawing.

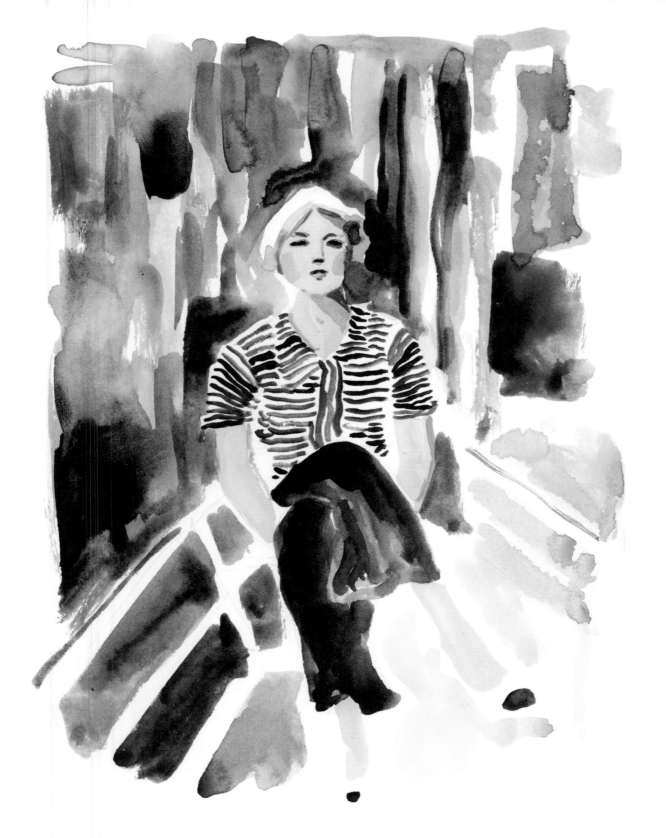

I WOULD HAVE FUN
WITH THE WAVES IN
HER HAIR

I LIKE TO MAKE THE WALL
A FUN BRIGHT COLOR
AND PATTERN

WHITE PEARLS ON
THE BLACK SWEATER
CREATE GREAT CONTRAST

YOU CAN PLAY WITH THE
PATTERN ON THE COUCH

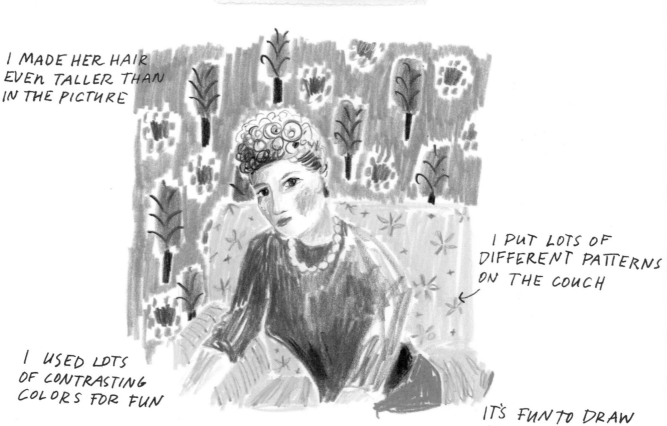

I MADE HER HAIR
EVEN TALLER THAN
IN THE PICTURE

I PUT LOTS OF
DIFFERENT PATTERNS
ON THE COUCH

I USED LOTS
OF CONTRASTING
COLORS FOR FUN

IT'S FUN TO DRAW
VERY LOOSELY

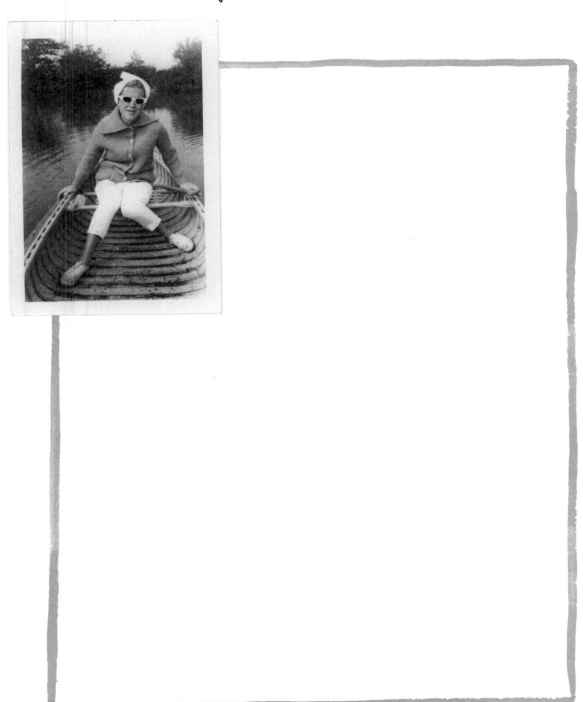

Do your own interpretation of the photo above.

DAY 82 __/__/__

Find another black and white photo to copy.
What colors do you imagine this person wearing?

DAY 83 __/__/__

Paste an old FAMILY PHOTO here and COPY it
(or juSt reFer to it aS you draw).

DAY 84 __/__/__

COPY another old Photo, PREFERABLY of SOMEONE unknown to you. MAYBE jot down a made-up name For this PeRSon and a caption FOR the image as Well.

REFLECTIONS

Do you have a favorite old photo of a parent, grandparent, or relative? An image that you love because it brings a younger version of that person to life? Try to imagine what this person must have been like at the age the photo was taken. Or just think about what he or she means to you.

DAILY DRAWING IDEA

COMBINE COLORFUL STRIPES WITH BLACK AND WHITE FLOWERS

Combining stripes and flowers in the same drawing feels fresh and playful—especially when the flowers are the black element. Start by filling some areas of the page with stripes: they can be monochromatic or multi-colored. Then add black-and-white flowers around your stripes. Playing with scale makes your composition dynamic. Alternate between pairing thin stripes with a large floral or very wide stripes with a scattering of flowers.

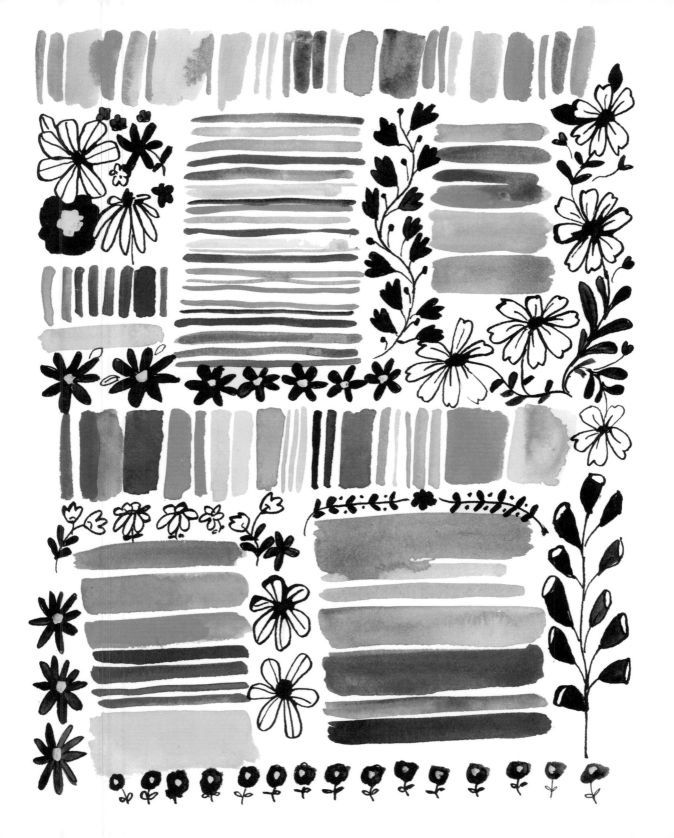

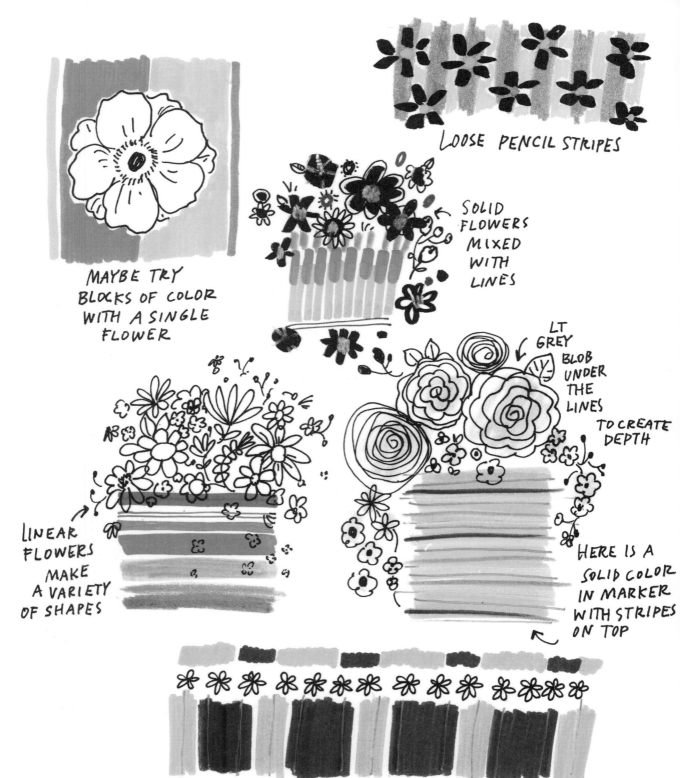

LOOSE PENCIL STRIPES

MAYBE TRY BLOCKS OF COLOR WITH A SINGLE FLOWER

SOLID FLOWERS MIXED WITH LINES

LT GREY BLOB UNDER THE LINES TO CREATE DEPTH

LINEAR FLOWERS MAKE A VARIETY OF SHAPES

HERE IS A SOLID COLOR IN MARKER WITH STRIPES ON TOP

BROAD STRIPES WITH LITTLE FLOWERS

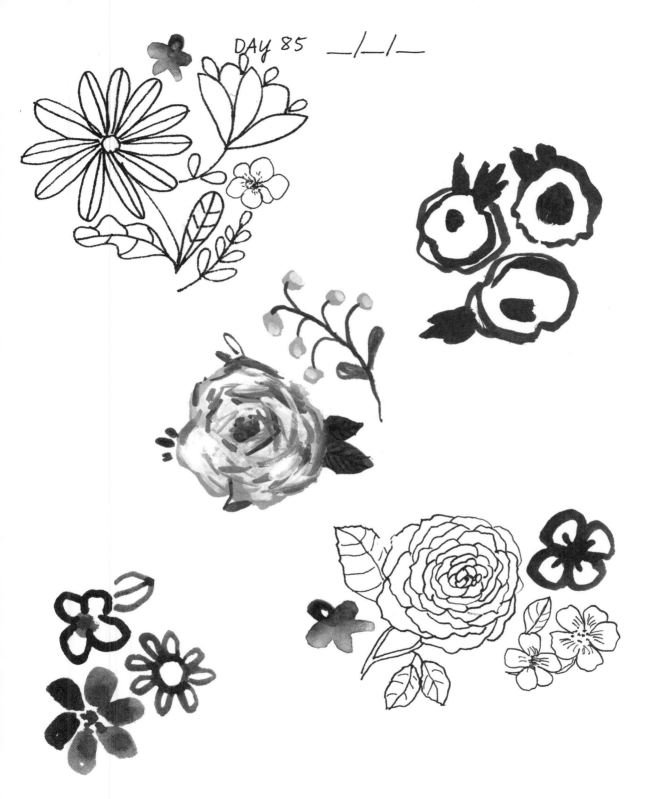

DAY 85 __/__/__

DRAW SOME STRIPES around these FLOWERS (and add MORE FLOWERS, too).

DAY 86 __/__/__

Pick a limited palette for the stripes in the design that you do today.

DAY 87 __/__/__

start with the FLOWERS FOR this design.

start with the stripes For this design.

DAY 88 __/__/__

REFLECTIONS

Pinstripes and lace. Peanut butter and jelly. A new season of your favorite TV show and a rainy day. Some combinations are just pure magic. What are some of your favorites?

DAILY DRAWING IDEA

DRESS animals in CLOTHES

Animals and clothes: Both are fantastic things to draw by themselves and so fun to combine together! Seeing a furry face coming out of a dress shirt or the patterns of a tiger mixing with the floral of a dress makes me smile. I love to play with different styles on random animals. Try drawing your pet in the clothes you are wearing today, an armadillo in medieval armor, or a bird in a jaunty hat and striped shirt. Or you can start with a human figure and top it off with an animal head. Anything goes here.

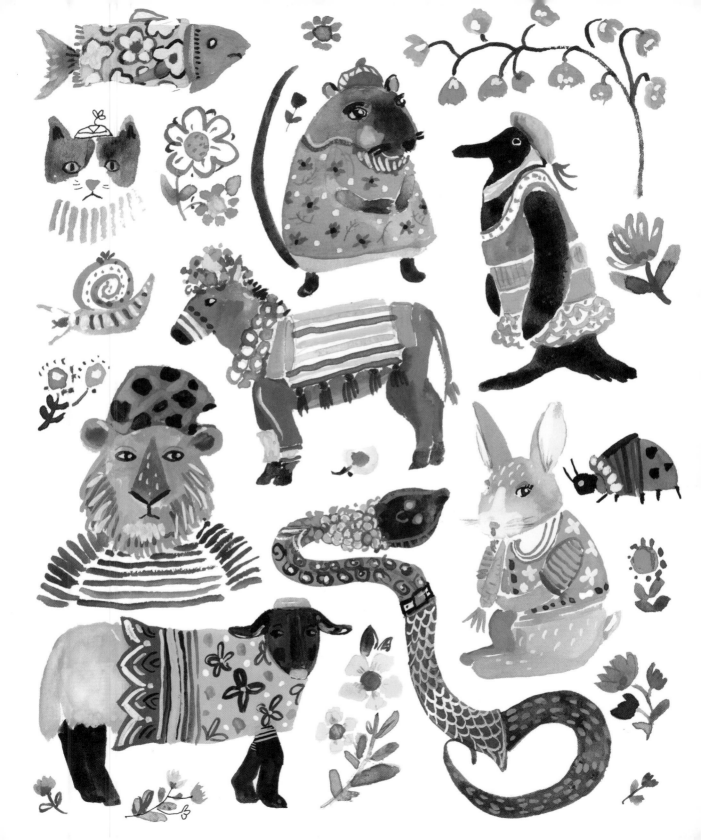

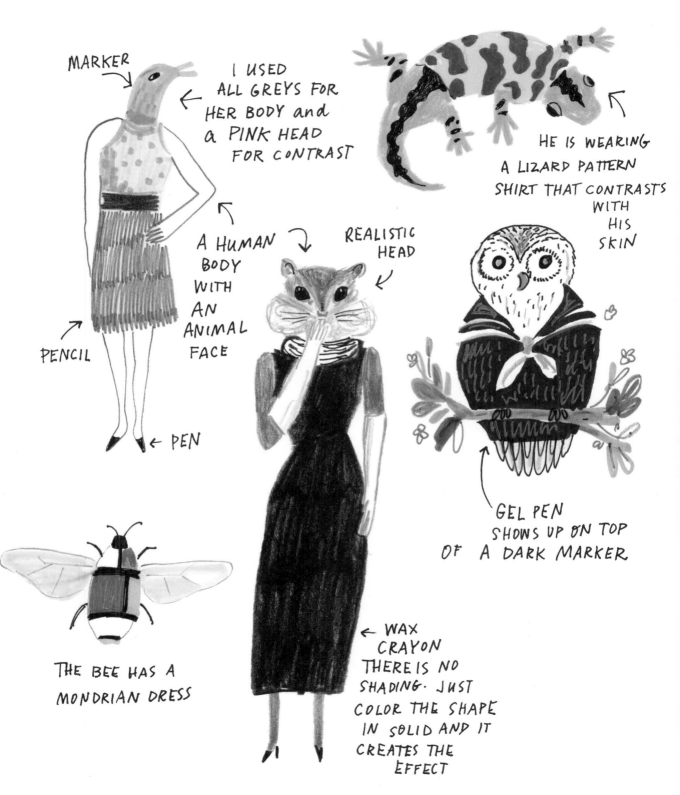

MARKER

I USED ALL GREYS FOR HER BODY and a PINK HEAD FOR CONTRAST

HE IS WEARING A LIZARD PATTERN SHIRT THAT CONTRASTS WITH HIS SKIN

A HUMAN BODY WITH AN ANIMAL FACE

REALISTIC HEAD

PENCIL

← PEN

GEL PEN SHOWS UP ON TOP OF A DARK MARKER

← WAX CRAYON THERE IS NO SHADING. JUST COLOR THE SHAPE IN SOLID AND IT CREATES THE EFFECT

THE BEE HAS A MONDRIAN DRESS

DAY 89 __/__/__

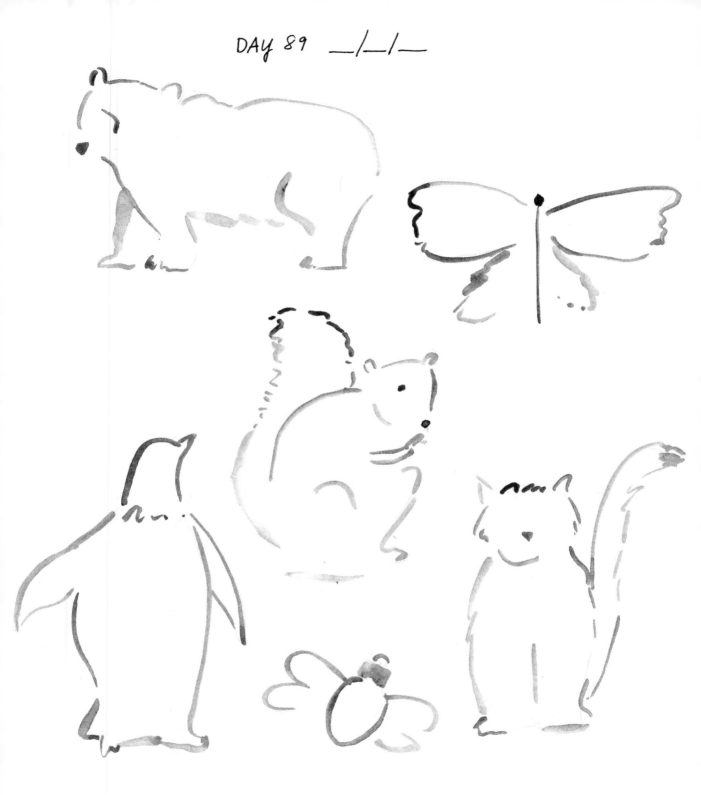

Give these animals some outfits!

DAY 90 __/__/__

What would an animal wedding party look like?

DAY 91 __/__/__

Dress one animal in four fantastic looks.

For Work

For a Party

For the Weekend

For Bed

DAY 92 __/__/__

maybe pair your favorite animal with your favorite outfit or a designer outfit?

REFLECTIONS

What is your spirit animal (the animal that inspires you or best represents your personality)?

DRAW a SELFIE and MAKE-UP the BACKGROUND

EVERY FEW WEEKS or so I take a SELFIE in MY BEDROOM MirroR With MY Phone. I usually do this When I've Put on a Particularly interesting outFit that I Want to Paint. I use the Photo as the BaSis For MY drawing, But I oFten change things uP. I might switch the color of MY skirt or create a Bolder Pattern on MY scarF. Then I take MYSELF out oF MY Surroundings and make a completely new Background. IF you don't have a Full-length MirroR or iF you don't like taking selFies, Please Feel Free to use Photos that others have taken oF you.

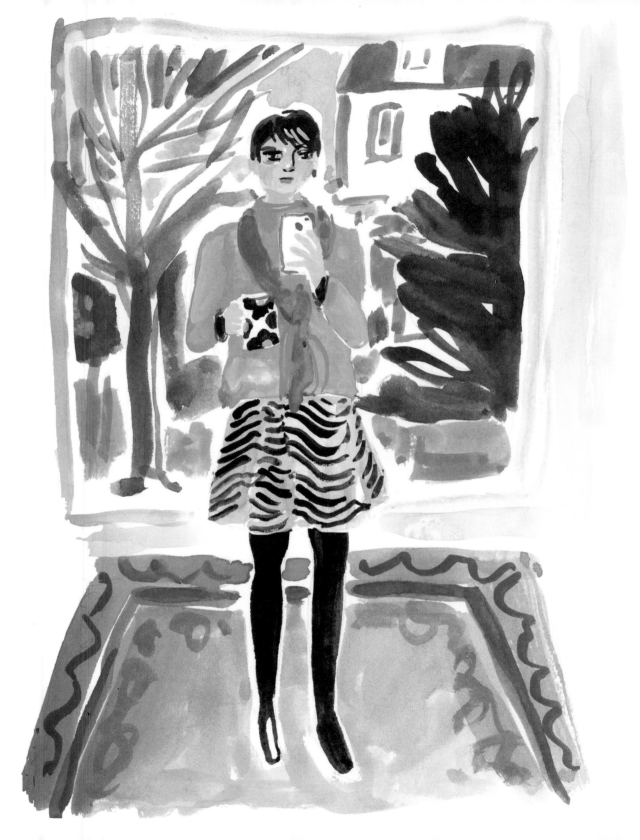

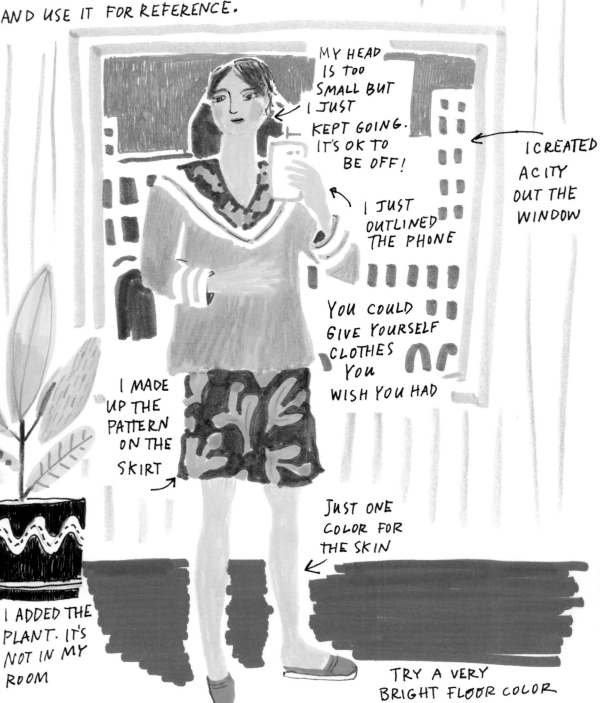

DAY 93 __/__/__

DRAW YOURSELF USING JUST BLACK-AND-WHITE PENCIL,
BUT FEEL FREE TO GET FANCIFUL WITH PATTERN.

DAY 94 __/__/__

Take a selfie in whatever you happen to be wearing today,
and draw it with a fantasy background.

DAY 95 _/_/_

DRAW YOURSELF IN A FAVORITE OUTFIT, BUT FEEL FREE
to EMBELLISH it even MORE in your DRAWING.

DAY 96 __/__/__

Do any type of self-portrait that you'd like today. You can refer to a photo, look in a mirror, or draw just one part of yourself (like your hands or feet).

REFLECTIONS

How do you feel about taking selfies?
What crosses your mind when you see
other people taking selfies?

DAILY DRAWING IDEA

COPY OLD MASTERS

I've drawn a 30 minute Rembrandt for fun! I enjoy taking very familiar art, looking at it carefully, and putting my own little twist on it. It's a fantastic way to see how a brilliant artist handles composition, light and dark, and pattern and color. I'm not trying to copy the work down to every detail. I limit my time so I'm forced to pare it down to its essentials. Try this with different periods of painting, from the Baroque to the Fauves.

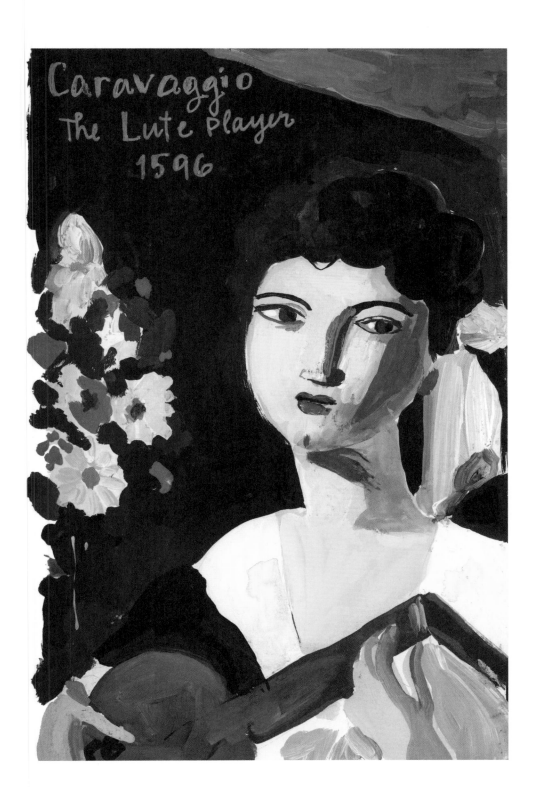

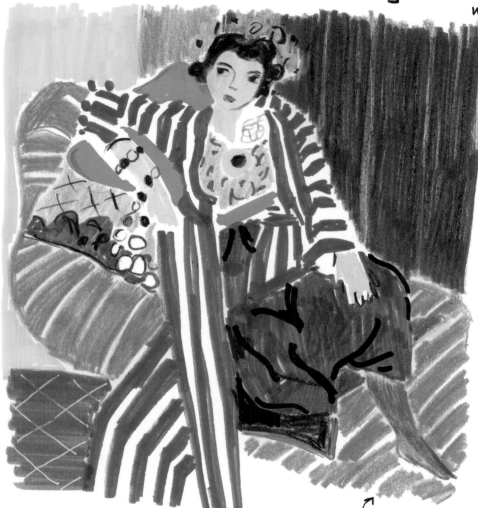

DAY 97 __/__/__

TRY YOUR MATISSE HERE.

DAY 98 __/__/__

choose a still life and copy it here.

DAY 99 __/__/__

select a portrait and copy it here.

DAY 100 __/__/__

COPY ANY WORK OF ART OF YOUR CHOICE.
IF YOU CAN GET TO A MUSEUM, TRY DRAWING FROM THE ORIGINAL.

REFLECTIONS

Copying is part of the learning process. Sometimes you need to emulate in order to originate! Who are your art heroes?

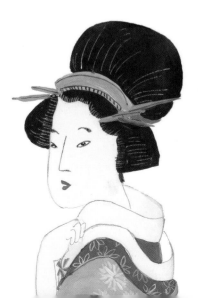

Designer: Hana Anouk Nakamura
ISBN: 978-1-4197-3217-1
© 2018 Jennifer Orkin Lewis
Type design by Kyle Letendre
Published in 2018 by Abrams Noterie, an imprint of ABRAMS. All rights reserved.
No portion of this book may be reproduced, stored in a retrieval system, or
transmitted in any form or by any means, mechanical, electronic, photocopying,
recording, or otherwise, without written permission from the publisher.
Printed and bound in China
10 9 8 7 6 5
Abrams Noterie products are available at special discounts when
purchased in quantity for premiums and promotions as well as fundraising
or educational use. Special editions can also be created to specification.
For details, contact specialsales@abramsbooks.com or the address below.

ABRAMS The Art of Books
195 Broadway, New York, NY 10007
abramsbooks.com